IMAGES
of America

SPRING BRANCH

IMAGES
of America

SPRING BRANCH

George Slaughter

ARCADIA
PUBLISHING

Copyright © 2011 by George Slaughter
ISBN 978-0-7385-8511-6

Published by Arcadia Publishing
Charleston, South Carolina

Printed in the United States of America

Library of Congress Control Number: 2011931883

For all general information, please contact Arcadia Publishing:
Telephone 843-853-2070
Fax 843-853-0044
E-mail sales@arcadiapublishing.com
For customer service and orders:
Toll-Free 1-888-313-2665

Visit us on the Internet at www.arcadiapublishing.com

For Cheryl and Kathy

CONTENTS

ACKNOWLEDGMENTS

This is not the first book on Spring Branch, nor will it likely be the last. Each generation makes its mark and has stories of its own to share. While the people I interviewed for this book have different views of what has been published to date, all agreed that the materials are useful places to begin research. The following titles are out of print but can be read and reviewed at the Clayton Library for Genealogical Research, a part of the Houston Public Library System: Karen Herridge's *Spring Branch Heritage* (Houston: Wakebrook Press, 1998); Alton M. Hocher's October 9, 1988, presentation at the 140-year anniversary of St. Peter Church; and a manuscript, *History of Spring Branch 1837–1937,* which has no listed author.

Several people deserve thanks for their help in the creation of this book. Kathy Carmichael of the Houston Public Library is a longtime Spring Branch resident who continues to have an interest in the area. Her guidance was helpful in the early stages of my research.

Nelda Blackshere Reynolds, like many of her fellow St. Peter Church parishioners, is a longtime Spring Branch resident who is also a descendant of the earliest settlers of the area—many of whom are buried in the cemetery directly behind the church. Nelda was a key resource in learning about both the church and the early settlers. She also helpfully pointed me to others who could share their knowledge of the area.

Patsy Andrews, the wife of Spring Valley mayor Michael Andrews, shared with me the *City of Spring Valley: Fifty Years 1955–2005,* a helpful book to which she was a key contributor.

Ruth Hillendahl Plumb was helpful in sharing stories and photographs, one of which is used for the cover of this book.

Thanks also go to Wayne Bamsch; Barbara Telschow Beach and her husband, Roland; Brandon Coleman Jr.; Ralph Devine of WestchesterWildcats.com; Doug Eschberger; Steve Griffin of HoustonHistory.com; Evelyn Schroeder Kingsbury and her husband, Robert; Terry Tully Ondriska; Bill Pielop; Tom Plagens; and Leonard and Joyce Vogt.

At Arcadia Publishing, my acquisitions editors Lauren Hummer and Kristie Kelly guided me through the technical processes used to create this book.

My biggest thanks go to two very special ladies. My mother, Cheryl Slaughter, died of cancer during the creation of this book. A native Houstonian and 39-year Spring Branch resident, she was always encouraging and enthusiastic about this project. I lament that Cheryl never got to see the finished book. Meanwhile, my longtime girlfriend, Kathy Rioux, accompanied me on the interviews, provided important feedback on the manuscript, and helped me compile the photographs for this book. I appreciate Kathy's encouragement and support. I dedicate Images of America: *Spring Branch* to them both.

INTRODUCTION

If you were to drive west from downtown Houston along Interstate 10 (known locally as the Katy Freeway), going outside Loop 610 but before reaching Beltway 8, you'd see businesses, hospitals, malls, restaurants, schools, strip centers, and subdivisions nestled among the trees. This area of town is known as Spring Branch, which, generally speaking, is bordered by US 290 to Clay Road on the north, Memorial Drive on the south, Loop 610 on the east, and the beltway on the west, though the Spring Branch Independent School District goes further west. Today, most people probably know Spring Branch for the school district. Spring Branch is a key residential and commercial section of Houston, and its location enables easy access to downtown and the Galleria shopping center on the West Loop at Westheimer. But things were not always this way.

German immigrants came to this area in the 1840s, during the time when the United States annexed Texas as the 28th state in the union, and Anson Jones, the last president of the Republic of Texas, said the republic was no more. This part of southeast Texas has numerous tributaries that lead to Buffalo Bayou, which in turn flows into a junction with White Oak Bayou, where the Allen brothers founded the city of Houston in 1836.

As for the area's name, Karl Kolbe, the first German immigrant settler in the area, was once asked what he called the place. Kolbe thought of the local tributary where he and his family had settled and said, "Spring Branch."

The area was remote from an already developing Houston, and was heavily wooded. The abundance of lumber was a good thing, as it was used to build the early local churches and businesses. Farming was the primary occupation for residents, but as industry began moving to the still unincorporated vicinity—Cameron Iron Works and Brown Oil Tools being among the most prominent examples—the farmland was sold and developed. Schools, shopping centers, and subdivisions became prevalent. Like so many other areas in Harris County, Spring Branch made the transformation from rural to urban. Houston annexed the Spring Branch area in the late 1940s.

Not all of the Spring Branch region was annexed, however. Some residents decided it would be better to incorporate their own municipalities, and today the Spring Branch area includes Bunker Hill Village, Hedwig Village, Hillshire Village, Hunters Creek Village, Piney Point Village, and Spring Valley.

Urbanization or no, Spring Branch continues to have ties to the past. Each year, horseback riders along the Salt Grass Trail Ride provide welcome reminders of that past as the Houston Livestock Show and Rodeo begins. At the same time, the growing school district works to help prepare students for the future in an increasingly multicultural community.

One

EARLY SETTLERS

Karl Kolbe, a farmer, emigrated from Gotha, Germany, in December 1845, arriving in Galveston, Texas, in March 1846, on the ship *Hamilton*. He made his way to a site that contained a tributary of Buffalo Bayou and named the stream Spring Branch Creek. (Courtesy Nelda Blackshere Reynolds.)

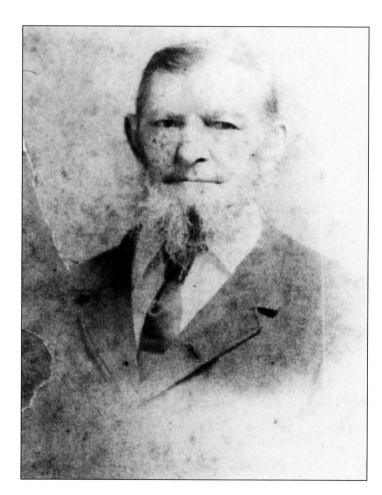

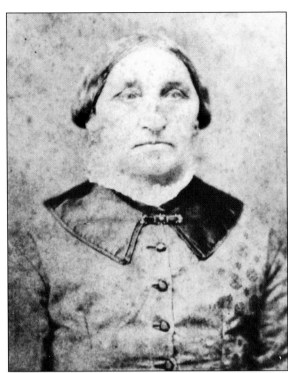

Like Karl Kolbe, Dorthea Kolbe was an immigrant to the United States. She came from Fallersleben, Germany, to Texas, and married Karl Kolbe in 1852. They had seven children. (Courtesy Nelda Blackshere Reynolds.)

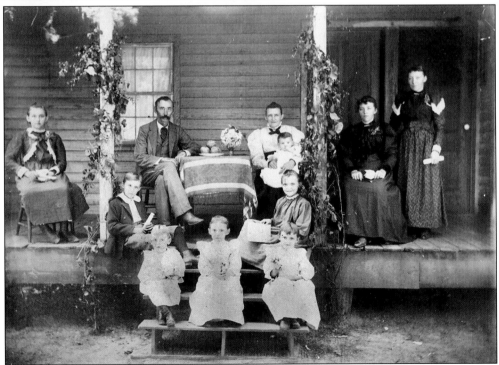

The Frank Kolbe family poses in this undated photograph. Frank, a son of Karl Kolbe, was a first-generation American. Frank married and raised his family in Cypress, which is northwest of Spring Branch. (Courtesy Nelda Blackshere Reynolds.)

Christian Beinhorn, a farmer from Osloss, Hanover, Germany, immigrated with his parents in 1853 on the ship *Suwa*. His parents were Johann Heinrich Dietrich Beinhorn and Anna Maria Dorothea Lehn Beinhorn. Beinhorn Road was named after Christian. He died of a spider bite in 1905. (Courtesy Nelda Blackshere Reynolds.)

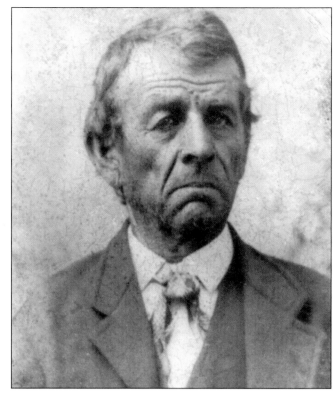

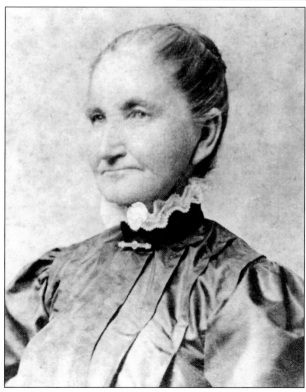

Marie (Mueller) Beinhorn was a German immigrant who married Christian Beinhorn in 1866. They had six children. (Courtesy Nelda Blackshere Reynolds.)

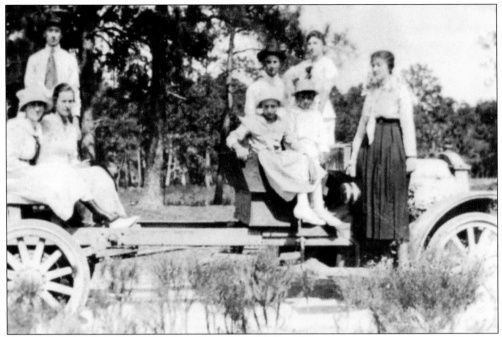

Members of the Bauer and Kolbe families pose for the camera in this undated image. Taking a drive in the country was a popular activity in the days before paved roads and traffic congestion. (Courtesy Nelda Blackshere Reynolds.)

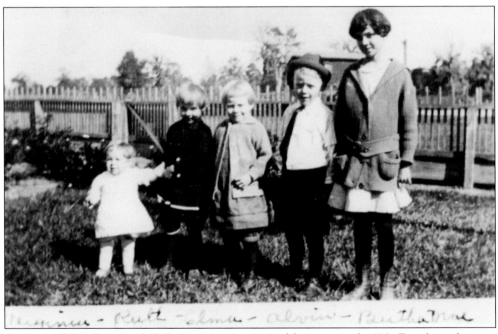

A group of Beinhorn and Kolbe cousins is pictured here around 1923. Family gatherings were frequent because so many relatives lived in proximity to each other. (Courtesy Nelda Blackshere Reynolds.)

Lilly Bauer poses for an undated photograph. Images such as these were infrequently taken because they were expensive. (Courtesy Nelda Blackshere Reynolds.)

Three Bauer family members pose for an undated photograph. (Courtesy Nelda Blackshere Reynolds.)

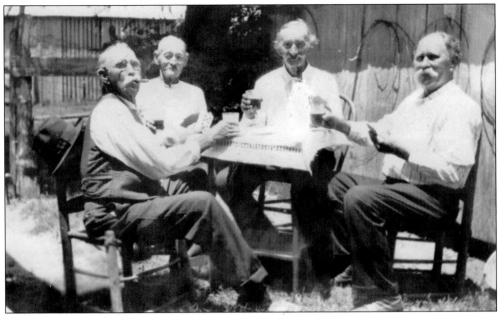

The Kolbe brothers enjoy a visit at a family reunion. Henry Kolbe is at right. (Courtesy Nelda Blackshere Reynolds.)

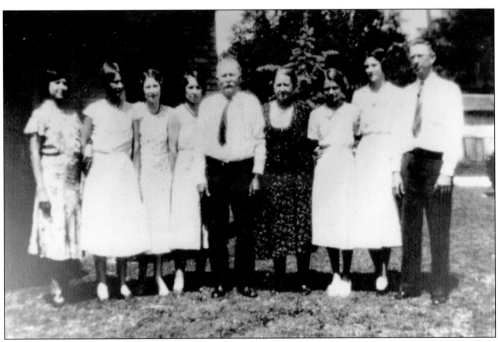

This image shows the family of Henry Kolbe. They are, from left to right, Tracy Kolbe Dilley, Marguerite Kolbe Sauer, Eva Kolbe Vogt, Cora Kolbe Eyring, Henry Kolbe, Bertha (Beinhorn) Kolbe, Ruth Kolbe Sauer, Bertha Mae Kolbe Blackshere, and Bob Kolbe. (Courtesy Nelda Blackshere Reynolds.)

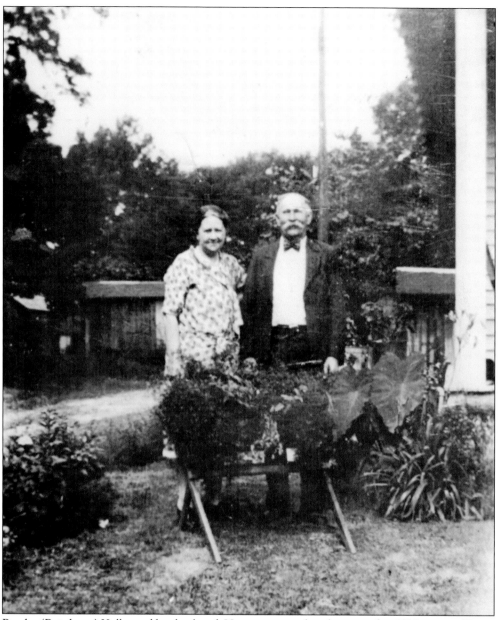

Bertha (Beinhorn) Kolbe and her husband, Henry, pose at their home in this 1930s image. Henry grew up in the original Kolbe home on Bingle Road, near the Spring Branch tributary. Bertha grew up in the original Beinhorn home on Campbell Road, near Katy Road. (Courtesy Nelda Blackshere Reynolds.)

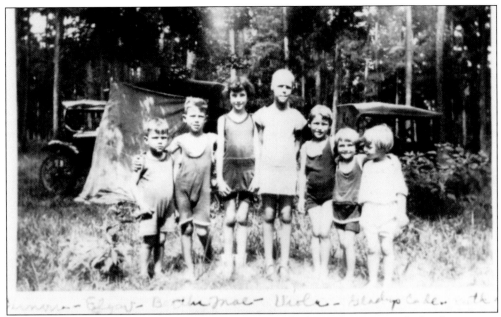

In this 1923 photograph, the Beinhorn and Kolbe cousins had gone for a swim at the local swimming hole, very likely the Spring Branch tributary. Wading in the creek was a popular activity in the days before swimming clubs and public pools. (Courtesy Nelda Blackshere Reynolds.)

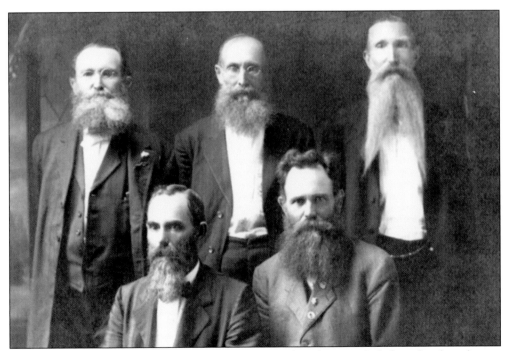

Heinrich and Elizabeth Hillendahl had five sons. In this photograph, believed to be taken in the late 1890s, Henry and Arnold Thomas Hillendahl are seated, while Theodore, George, and Louis Hillendahl are standing. (Courtesy Ruth Hillendahl Plumb.)

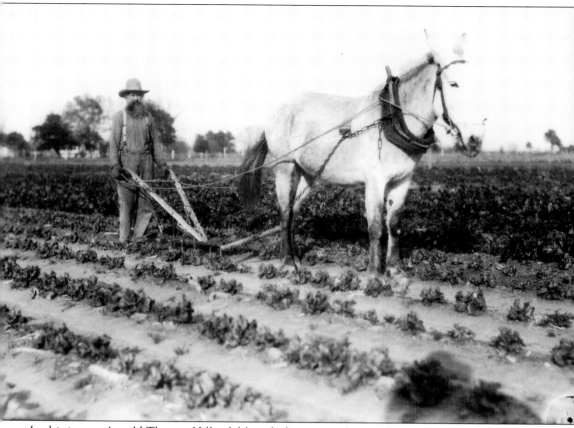

In this image, Arnold Thomas Hillendahl works his gray mule, Dinah. The family grew mostly produce, including cantaloupes, watermelons, tomatoes, cabbages, cauliflowers, green beans, and okra. (Courtesy Ruth Hillendahl Plumb.)

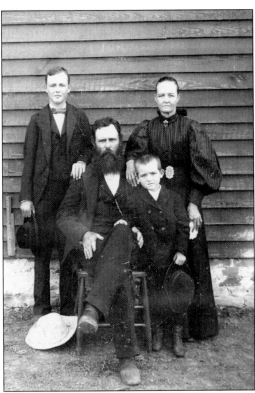

Arnold Thomas Hillendahl poses with his family in this photograph, believed to be taken in the early 1900s. Clockwise from left are Hillendahl's son Fritz; wife, Maria; and son Arnold Louis. (Courtesy Ruth Hillendahl Plumb.)

The Arnold Thomas Hillendahl homestead was located at 8325 Long Point Road, which was once Route 8, Box 58. Arnold Thomas was the son of Heinrich Hillendahl, who came to Texas from Hanover, Germany, and was one of the original settlers in the Spring Branch area. (Courtesy Ruth Hillendahl Plumb.)

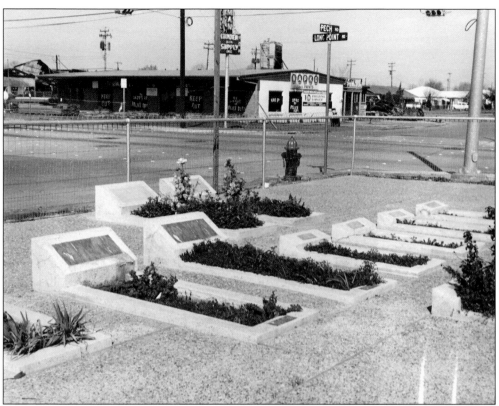

Heinrich Hillendahl decided that he wanted to be buried on his property when he died. The Hillendahl family created a small family cemetery at the northeast corner of their farm, which is now the southeast corner of the intersection of Pech and Long Point Roads. Although the area urbanized and the farm was eventually sold, the cemetery remained and was fenced off from further development. (Courtesy Ruth Hillendahl Plumb.)

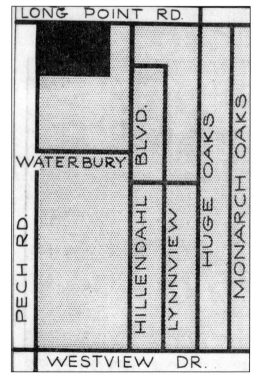

This diagram shows the Hillendahl family farm layout. The black square in the top left corner denotes the family cemetery on the northwest corner of the property. (Courtesy Ruth Hillendahl Plumb.)

"Historic cemeteries serve as directories of early residents and reflect the cultural influences that helped shape our state's communities."

F. Lawrence Oaks,
Executive Director of the Texas Historical Commission

Mrs. Bowers' Texas history class at Memorial Middle School had just finished studying historical markers. She taught her students the purpose of the markers and why they are important to our state. Shortly thereafter, the Spring Branch Multicultural Society sponsored an essay contest on "The History of Spring Branch". Mrs. Bowers had her students enter the contest. As the students were researching, the name Hillendahl was often mentioned. Several of the students visited the Hillendahl cemetery. They saw the cemetery dated back to 1854 and wondered why this cemetery had no historical cemetery marker! The class decided to apply for the marker and the Texas Historical Commission approved the application. This has been a year long project and a great history lesson for the students.

Welcome	Mr. Al Davis Harris County Historical Commission
Pledge of Allegiance	Miss Megan Livingston
Texas, Our Texas	Alex Riddle
Historical Marker Project	Mrs. Susan Bowers Memorial Middle School History Teacher
Hillendahl Family History	Miss Regan Jones
Unveiling of the marker	Miss Jordan Phillips 2003-2004 "History of Spring Branch" essay contest winner
By Cool Siloam's Shady Rill	Mr. Robert Wylie
Presentation of Certificates	Drew Busmire
Closing	Mrs. Susan Bowers

This is the program used at the May 22, 2005, dedication of the Hillendahl Family Cemetery. Present-day Commuters on Long Point Road pass the cemetery, which is located at the Pech Road intersection. (Courtesy Ruth Hillendahl Plumb.)

Form P.—District.

TRUSTEE'S COMMISSION.

THE STATE OF TEXAS,}
County of *Harris*

This is to Certify, That *Mr. A. Hillendahl* being a resident voter in District No. 27 in *Harris* County, and able to read and write, has been duly {ELECTED / APPOINTED} and having taken the oath of office, is hereby commissioned as School Trustee of the *Schools* of District No. 27 for the year beginning July 1st, 18*73* and ending June 30th, 18*74*

Given under my hand and seal of office, at *Houston* this 14*th* day of *July* 18*73*

(Seal)

B. L. James

County [illegible] Superintendent.

This 1893 trustee's commission officially certifies Arnold Thomas Hillendahl's appointment as a District 27 (later Spring Branch) school trustee. (Courtesy Ruth Hillendahl Plumb.)

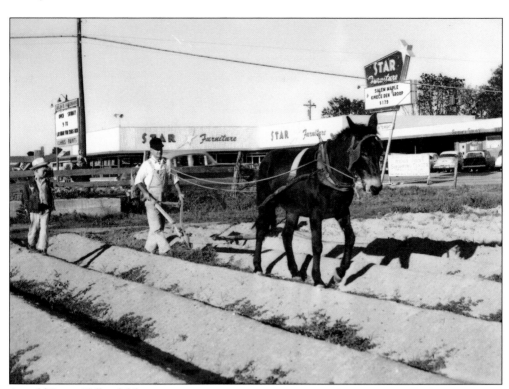

Arnold Louis Hillendahl works on his family farm. Hillendahl was active in the Spring Branch community, serving as a Spring Branch Independent School District trustee. (Courtesy Ruth Hillendahl Plumb.)

Arnold Louis Hillendahl walks on the family farm. He was active in St. Peter Church, helping to organize and put on the annual barbecues each October. Like his father, Arnold Thomas Hillendahl, Arnold Louis was known for his leadership in the Spring Branch Independent School District. (Courtesy Ruth Hillendahl Plumb.)

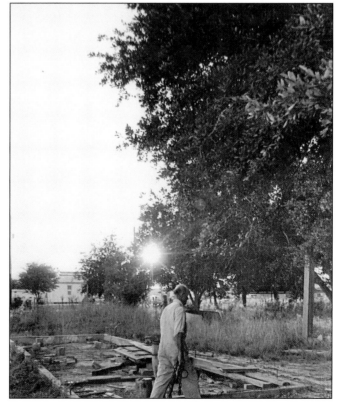

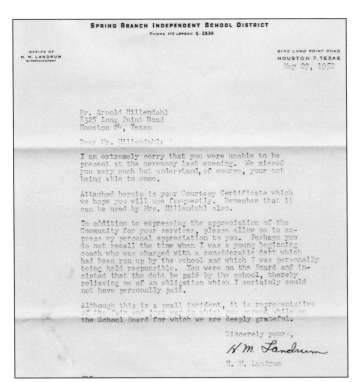

In May 1952, Spring Branch Independent School District superintendent H.M. Landrum wrote to thank Arnold Hillendahl for his service as a member of the school board. Landrum enclosed in the letter a courtesy certificate that Hillendahl and his wife could use for attending school district–sponsored events. (Courtesy Ruth Hillendahl Plumb.)

The inscription on the back of the courtesy certificate reads, "We realize that the value of this card in monetary terms is insignificant, but we do believe that as a symbol of honor and respect it is invaluable. Presentation of this card will admit you as our guest to any and all events sponsored by the school system." (Courtesy Ruth Hillendahl Plumb.)

Arnold Louis Hillendahl sits on a pile of bricks that was once the barn on the family farm. The 12-acre farm was sold in 1962 after being in the family for three generations. (Courtesy Ruth Hillendahl Plumb.)

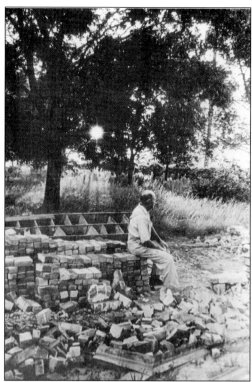

Henrietta Viola Williams Hillendahl, informally known as "Etta," stands on the Hillendahl family farm. She was active in both the women's guild at St. Peter Church and the sewing groups that were popular social activities at the time. (Courtesy Ruth Hillendahl Plumb.)

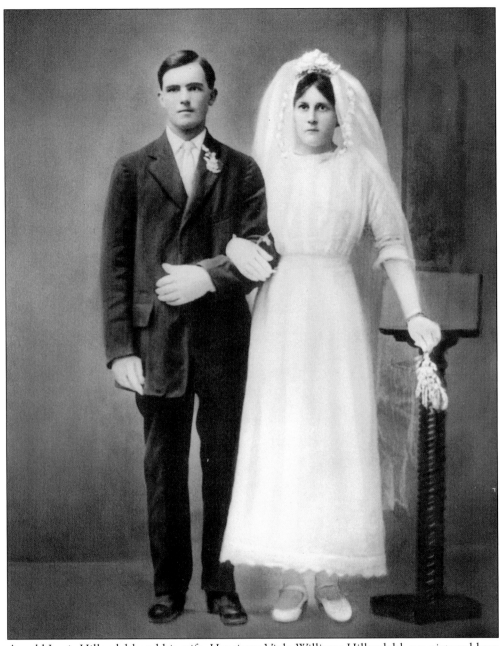

Arnold Louis Hillendahl and his wife, Henrietta Viola Williams Hillendahl, are pictured here on their wedding day, September 12, 1912. (Courtesy Ruth Hillendahl Plumb.)

State and County Tax Receipt.

No. *1285* Received, *June 20* 1877

of *Mary Hillendahl*

Seven 72/100 Dollars,

in payment of Taxes for the year 1875

upon the following described property:

	State Poll Tax,	
	" Advalorem,	3 50
	" Interest,	
	Co. Advalorem,	1 75
	" Special Tax,	2 10
	Roads & Bridges,	35
	County Interest,	7 70

No. of ABS'T	ORIGINAL GRANTEE	No. ACRES	COUNTY	LOTS	BL'KS	OUT LOTS	MISCELLANEOUS	VALUE
	H. Tierwester	80						500
			2 Horses					70
			13 Cattle					75
			Vehicle					55
								700

Nathan T Davis

Sheriff *____ Harris* Co.

This is an 1875 state and county tax receipt for $7.70, received June 20, 1877. At the time, the Hillendahl family farm had two horses, 13 head of cattle, and one vehicle. (Courtesy Ruth Hillendahl Plumb.)

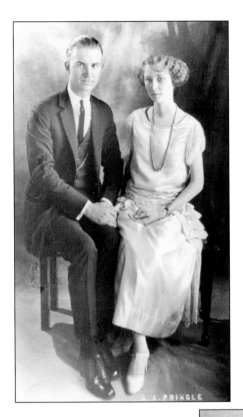

G.A. Pringle, a commercial photographer of the day, took this portrait of Louis Sauer and Marguerite Kolbe on their July 22, 1924, wedding day. (Courtesy Nelda Blackshere Reynolds.)

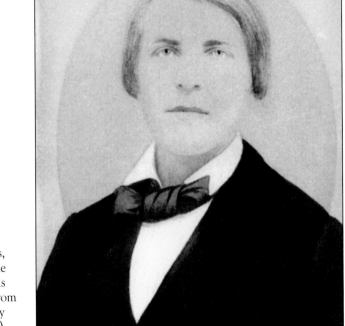

Jacob Schroeder, a farmer, was among the first settlers in the Spring Branch area. He came to Galveston, Texas, from Germany about the time the area became settled. He is believed to have emigrated from a town near Berlin. (Courtesy Evelyn Schroeder Kingsbury.)

Louie Schroeder, a son of Jacob Schroeder, and his wife, Lana, had a farm on Piney Point, near Katy Road. Family lore states that even though they spoke English, the adults conversed in German when they hosted family events. (Courtesy Evelyn Schroeder Kingsbury.)

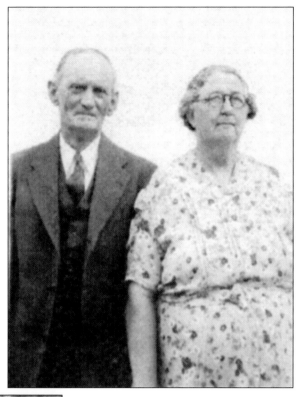

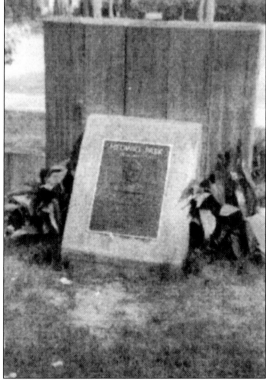

Hedwig Schroeder, wife of Henry Schroeder and daughter-in-law of Jacob Schroeder, was a longtime area resident. She donated land for Hedwig Road, and Hedwig Village and Hedwig Park were named in her honor. This dedication plaque is in Hedwig Park. (Courtesy Evelyn Schroeder Kingsbury.)

27

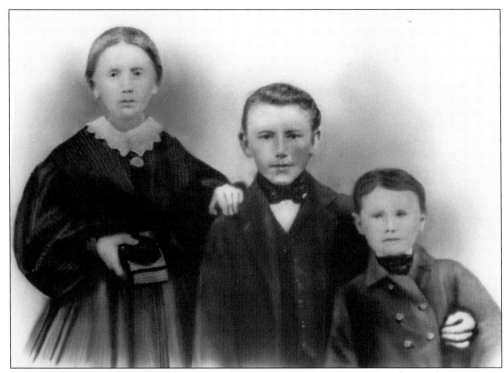

Family lore has it that August Neuen, a farmer, was going to be conscripted to Prussian military service in the era before German unification. Instead, he decided to immigrate to Galveston, Texas—and ultimately to the Spring Branch area—in the 1870s. August is flanked by his brother and sister in this photograph, which was taken in Germany. (Courtesy Bill Pielop.)

Emma Neuen was the daughter of August Neuen. She was born in 1881 and confirmed in her faith at St. Peter Church in 1895, when she was 14 years old. Her confirmation Bible, which was awarded at the ceremony, was printed in German, a common practice of the day. (Courtesy Bill Pielop.)

Will Beinhorn worked on his family farm, which was at the southeast corner of Campbell Road and Katy Road, until his father's death in 1905. Will Beinhorn and his mother ran the farm until 1910, when Will became involved in the meat and grocery business. This is a January 1, 1923, receipt for a sale totaling $7.20 from the store, located at the intersection of 27th and Yale Streets in the Heights area of Houston. (Courtesy Bill Pielop.)

W. A. BEINHORN
MEATS, GROCERIES AND FEED
Phone Taylor 2429 27th and Yale Sts.

Houston Heights, Texas,................................*192.....*

Name ...

Address ...

Sold by | ACCOUNT FORWARDED |

Emma and Will Beinhorn are dressed for church. The photograph was supposedly taken in the early 1960s. The Beinhorns married on April 10, 1912, which was the Wednesday before the RMS *Titanic* sank on April 15. Will Beinhorn was born in the Spring Branch area in 1879. (Courtesy Bill Pielop.)

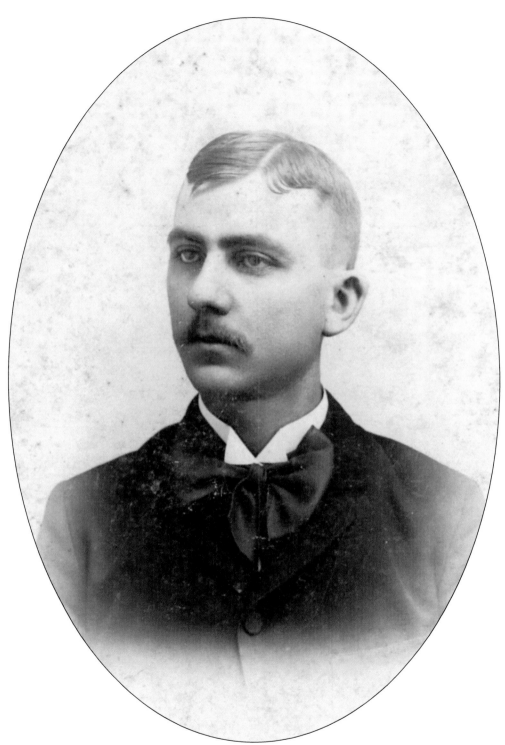

Albert Beinhorn, a farmer, was a brother of Will Beinhorn. Albert's farm was believed to be near Mangum Road in northwest Harris County, outside the Spring Branch area. He is buried in the cemetery behind St. Peter Church. (Courtesy Bill Pielop.)

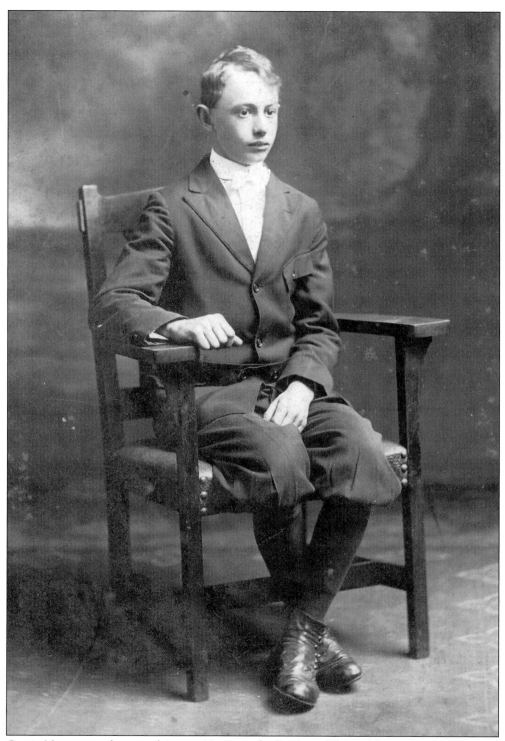

Gussie Neuen was the son of August Neuen and a brother of Emma Neuen Beinhorn. Gussie died of an infection at age 18. This is believed to be his confirmation photograph from St. Peter Church. (Courtesy Bill Pielop.)

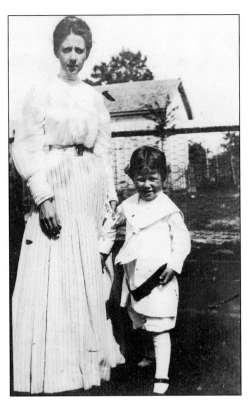

Dora Beinhorn Noack poses with her son D. Armand Noack in a photograph taken in the early 1900s. Dora and her twin sister, Etta, were daughters of Christian and Marie Mueller Beinhorn. Dora married and moved to the Heights, which was then on the western outskirts of Houston. (Courtesy Bill Pielop.)

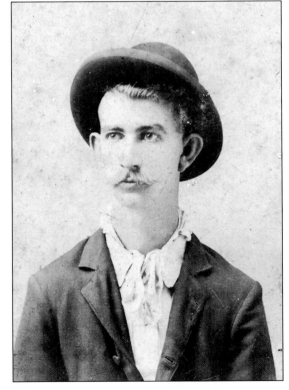

Louis Beinhorn was the brother of Albert and Will Beinhorn. He worked on his family farm and, like Gussie Bauer, died prematurely, in this case of complications following a horseback-riding accident. (Courtesy Bill Pielop.)

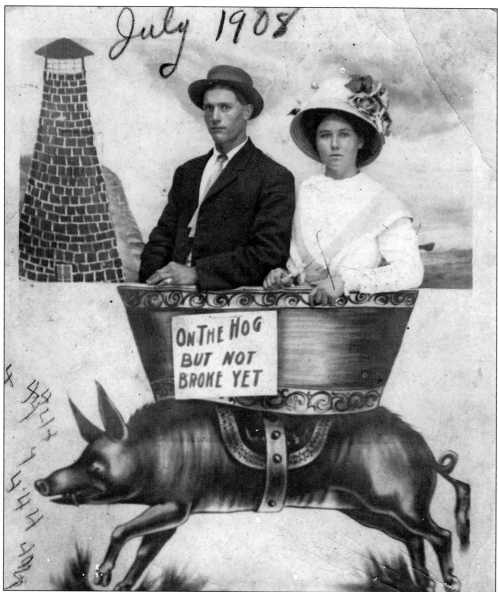

Ed Telschow, pictured here with his wife, Tracy, at a July 1908 local carnival, was the son of immigrants from Kyritz, Brandenburg, Germany, who settled in the Addicks area, which is near the present-day intersection of State Highway 6 and Westheimer Road. (Courtesy Barbara Telschow Beach.)

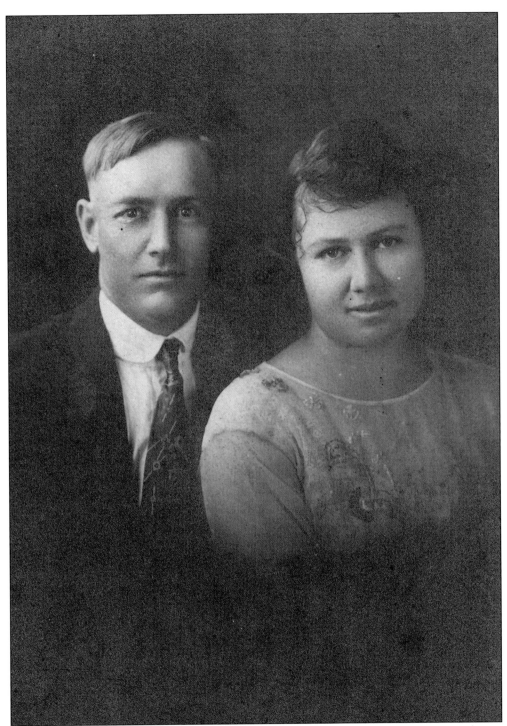

After growing up in Addicks, Ed Telschow moved to the Spring Branch area, where he became a farmer. Later, he became a baker at Weingarten's Grocery Store on Washington Street, east of Spring Branch and closer to Houston. Tracy Telschow was a seamstress. (Courtesy Barbara Telschow Beach.)

No. 3 __ **OFFICE OF COLLECTOR OF TAXES,**
Harris County.

TAXES
State ad valorem $ 2 05
County " 2 58
Revenue & School poll
County poll
Dog

RECEIVED OF *Caroline Rummel*
the following amounts, in payment of State and County Taxes
for the year 1877, on personal property and the following described real estate:

Total $ 4 63

				LANDS		TOWN LOTS			
Abst No	No of Acres	Cert No	Survey No	Original Grantee	Lot No	Block No	Out lot No		
428	25			A. H. Osborne				#10	
0	6			Morton					
371	125			Thos Haskin					
	7								

Houston Texas, *May 11th* 1878 *Nelson Davis* Coll

R. Williams 100

R. Vince 63 130

W. R. Morton 1628 250

20 Horses 380

25 Cattle 120

Miscell. 40 460

Add 20% 17 85
3 57
21 42

Twenty one 42/100 dollars 2,040

S. S. Ashe Sheriff Harris Co.
pr Connel.

Jan 18__ Sheriff *Daniel S. Ashe* County.
pr __

ACY. State Printer.

This 1878 State of Texas and Harris County tax receipt for $4.63 is for four tracts of land—25 acres, 125 acres, 7 acre, and 6 acres—all owned by the Rummel family. This receipt was stitched onto the other tax receipts behind it. (Courtesy Doug Eschberger.)

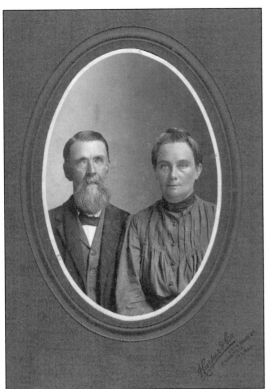

This photograph shows Henry and Lina (Rummel) Sauer. Henry was a farmer and met Lina after moving to Texas. Rummel Creek and, in time, the Rummel Creek Elementary School in western Spring Branch were named for the Rummel family. (Courtesy Doug Eschberger.)

Conrad Sauer Sr., pictured here with his wife, Mary Helena (Wyman) Sauer, retired from dairy farming and went to work for longtime Harris County commissioner E.A. "Squatty" Lyons, who told him that the city of Houston had a Sauer Road near downtown, and the Sauer Road in Spring Branch had to be renamed to avoid confusion. The Spring Branch roadway was thus renamed Conrad Sauer Drive. This street runs north and south and is located west of Gessner Road, east of the West Sam Houston Tollway, and north of Interstate 10. (Courtesy Doug Eschberger.)

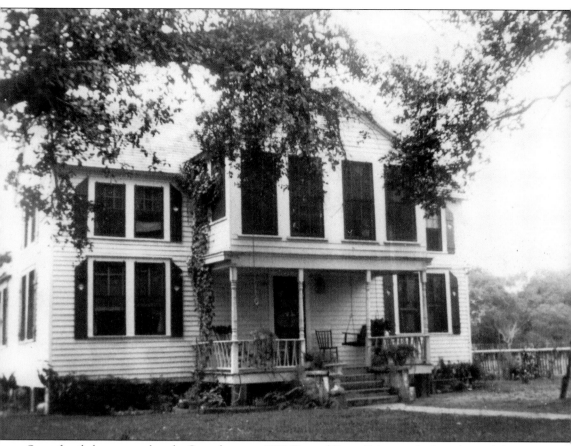

Sauer family lore states that the Sauer home at 1209 Conrad Sauer Drive was built with wood that washed up in Buffalo Bayou following the 1900 hurricane that hit Galveston and the Texas coast. In the days before air-conditioning, there was a large attic fan on the second floor that cooled the house. The residence was destroyed by arson in the 1980s. (Courtesy Doug Eschberger.)

Barbara Telschow poses in front of the farmhouse. The Telschow farm was on the east side of Gessner Road, north of Neuens Road and south of Hammerly Boulevard. A heavily wooded golf course was on the west side of Gessner Road, opposite the farm. The golf course property was eventually purchased by the Spring Branch Independent School District and became the site of Spring Woods High School, Spring Oaks Middle School, Westwood Elementary School, Tiger Trail School, and the school district's W.W. Emmons Natatorium. In 2010, Westwood Elementary School was moved to a new campus nearby on Hammerly Boulevard. The original Westwood Elementary School building has been used as a temporary location for other elementary schools while those buildings are being reconstructed. (Courtesy Barbara Telschow Beach.)

Two

CHURCHES

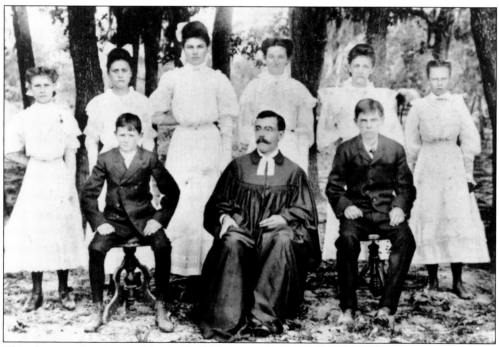

This photograph, taken on March 29, 1907, shows a St. Peter Church confirmation class. Pictured are, from left to right, (first row) Charlie Telschow, the Rev. Carl August Stadler, and Conrad Sauer; (second row) Hilda Oberpriller, Katie Witte, Nettie Hillendahl, Marie Schaper, Emma Riedel, and Louise Hobright. (Courtesy St. Peter Church.)

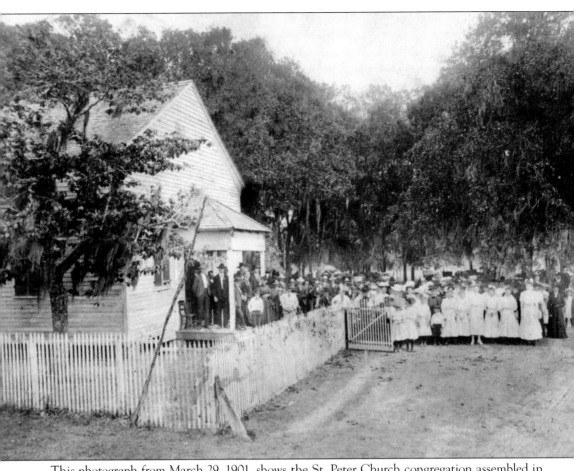

This photograph from March 29, 1901, shows the St. Peter Church congregation assembled in front of the church. The building shown here is the second to serve as the church; a fire destroyed the original log cabin structure. A confirmation class is assembled in the front of the photograph. (Courtesy St. Peter Church.)

The St. Peter Church steeple was built in 1924. In 1967, the Texas Historical Commission placed a marker to denote the historic status of the church, and the marker remains in front of the structure today. (Courtesy St. Peter Church.)

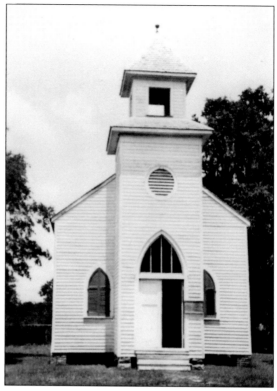

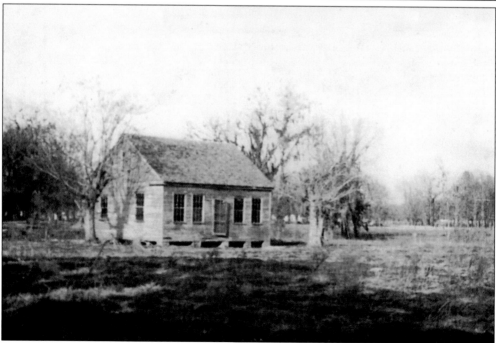

Pictured here is the first parsonage, or home for the clergy, at St. Peter Church. The church site, on Long Point Road, is situated near the Spring Branch tributary of Buffalo Bayou that flows into Houston. (Courtesy St. Peter Church.)

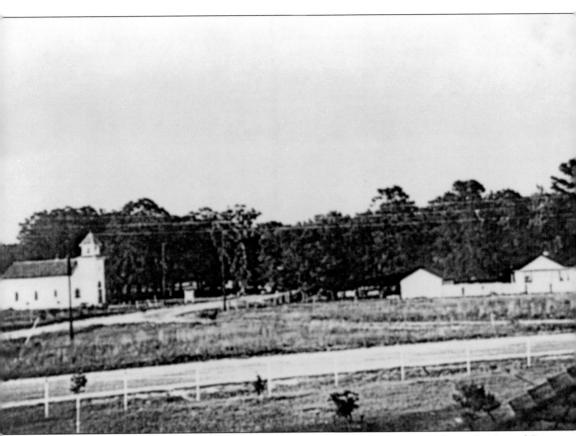

This 1950 photograph, taken from the roof of a nearby house, shows a wide-angle view of St. Peter Church. Campbell Road curves in the foreground, and Long Point Road runs in front of the church. (Courtesy St. Peter Church.)

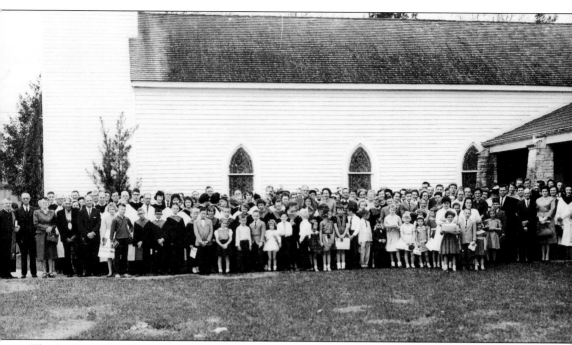

The St. Peter Church congregation gathers for a 1961 photograph. It was taken to commemorate the move from the small, original church building to the larger, more contemporary sanctuary constructed nearby. (Courtesy St. Peter Church.)

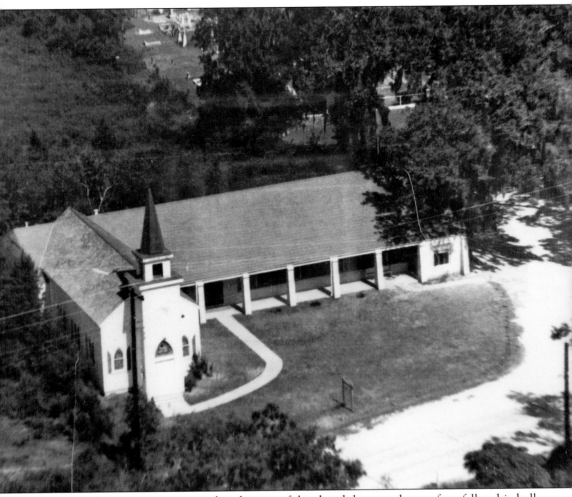

In 1945, the sanctuary was moved to the west of the church lot to make way for a fellowship hall. Alton Hocher took this photograph after asking a friend, a pilot with a small airplane, to fly over the church. The image was supposedly taken in 1949. The section with a window at the right of the fellowship hall served as the pastor's office. It was torn out when a council room and a new, larger sanctuary were built in 1961. (Courtesy St. Peter Church.)

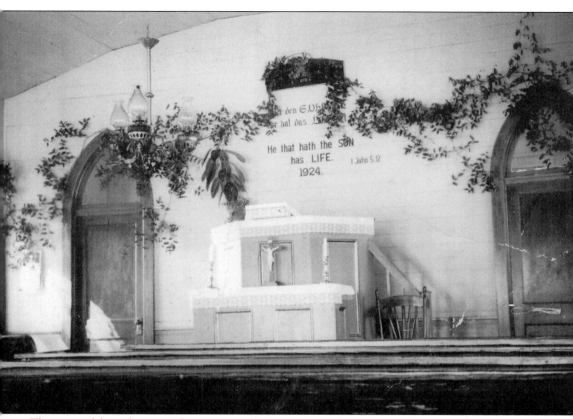

This view of the pulpit was taken in 1924. The scripture on the wall is 1 John 5:12: "He that hath the SON has LIFE." The verse appears in German just above the English citation. (Courtesy St. Peter Church.)

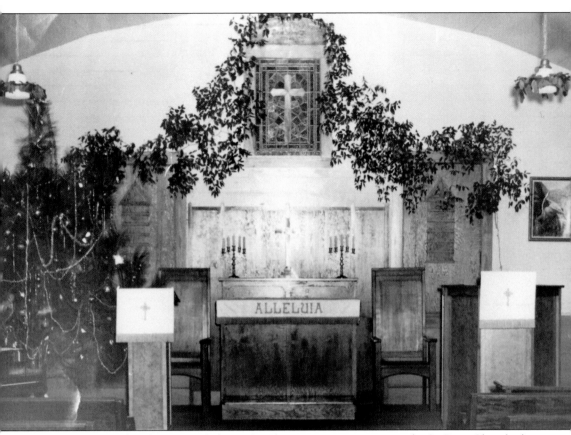

This photograph, taken in 1945, shows the Christmas arrangements at the St. Peter Church altar. (Courtesy St. Peter Church.)

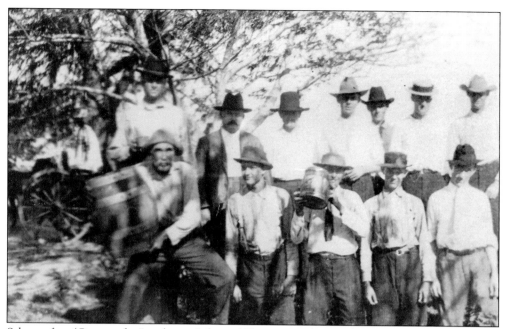

Schutzenfests (German for "marksman's festivals") were popular social occasions for Spring Branch residents. They provided a welcome break from the challenges of building a community, raising families, and making ends meet. (Courtesy Nelda Blackshere Reynolds.)

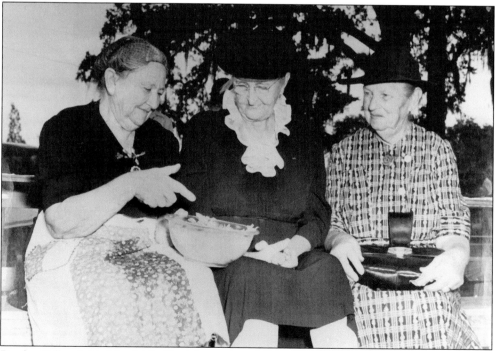

Bertha Kolbe (left), Mrs. M.E. Herd (center), and Kate Reichert enjoy themselves at a church barbecue. The church hosted an annual barbecue each October to celebrate its anniversary. (Courtesy Nelda Blackshere Reynolds.)

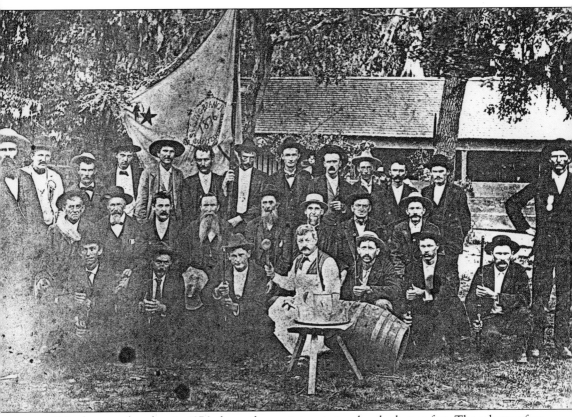

This photograph, taken in 1876, shows the participants in a local schutzenfest. The schutzenfest was an all-day event that included a gun-shooting contest, a picnic, games, and a dance. It was held near the present-day location of the Memorial Shooting Center and Gun Range on Witte Road. (Courtesy Nelda Blackshere Reynolds.)

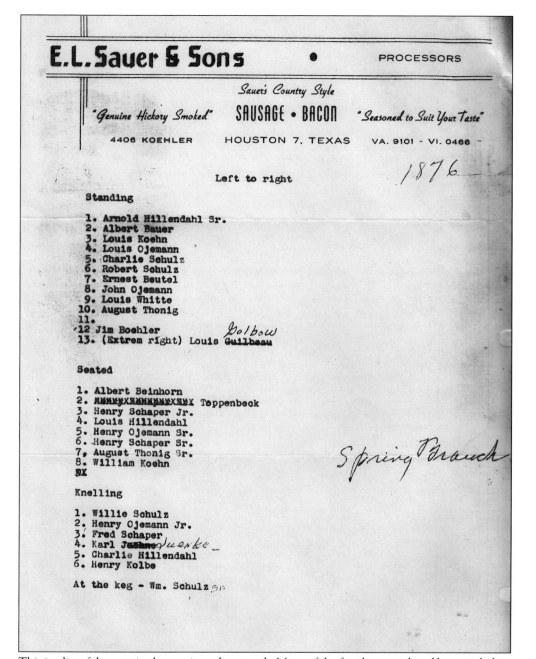

E.L. Sauer & Sons • PROCESSORS

Sauer's Country Style

"Genuine Hickory Smoked" SAUSAGE • BACON *"Seasoned to Suit Your Taste"*

4406 KOEHLER HOUSTON 7, TEXAS VA. 9101 - VI. 0466

1876

Left to right

Standing

1. Arnold Hillendahl Sr.
2. Albert Bauer
3. Louis Koehn
4. Louis Ojemann
5. Charlie Schulz
6. Robert Schulz
7. Ernest Beutel
8. John Ojemann
9. Louis Whitte
10. August Thonig
11.
12 Jim Boehler
13. (Extrem right) Louis ~~Guilbeau~~ *Dolbow*

Seated

1. Albert Beinhorn
2. XXXXXXXXXXXXXXXXX Teppenbeck
3. Henry Schaper Jr.
4. Louis Hillendahl
5. Henry Ojemann Sr.
6. Henry Schaper Sr.
7. August Thonig Sr.
8. William Koehn
9X

Knelling

1. Willie Schulz
2. Henry Ojemann Jr.
3. Fred Schaper
4. Karl ~~Juehne~~ *Juenke*
5. Charlie Hillendahl
6. Henry Kolbe

At the keg - Wm. Schulz *Sr.*

Spring Branch

This is a list of the men in the previous photograph. Many of the family names listed here, including Hillendahl, Bauer, Koehn, Ojemann, Beutel, Witte, Schulz, Beinhorn, Schaper, and Kolbe, were among those of the first settlers in Spring Branch. (Courtesy Nelda Blackshere Reynolds.)

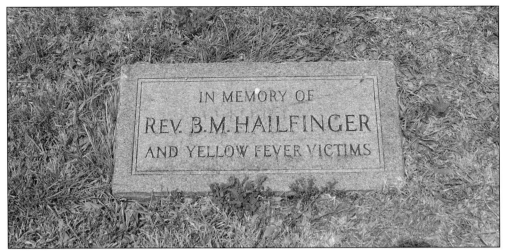

In 1859, a yellow fever epidemic swept through Spring Branch. The Rev. B.M. Hailfinger was one of many casualties of this outbreak. He and other victims are buried in the cemetery directly behind St. Peter Church. The burial ground contains the graves of many of the earliest Spring Branch settlers. (Photograph by George Slaughter.)

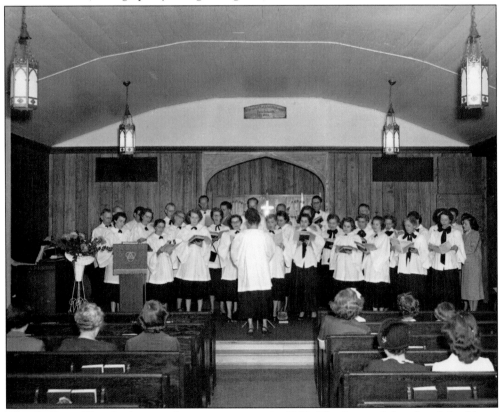

The St. Peter Church choir performs at a service in 1948. The front of the church had been expanded to accommodate a growing congregation, but when the new sanctuary was built, the extension was removed and the old chapel was returned to its original configuration. (Courtesy St. Peter Church.)

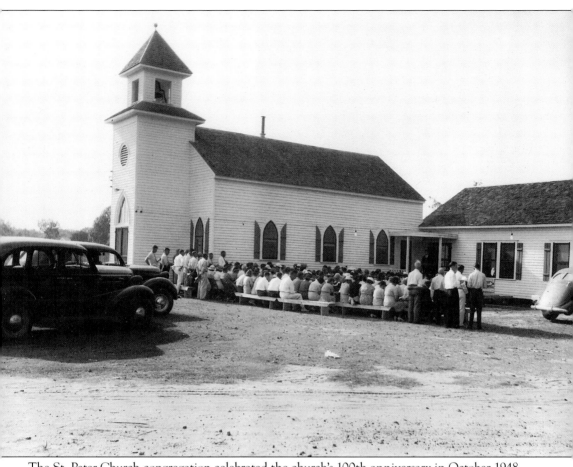

The St. Peter Church congregation celebrated the church's 100th anniversary in October 1948. By Easter 1948, the church had a membership of 200, and the Sunday school had an enrollment of 150. (Courtesy St. Peter Church.)

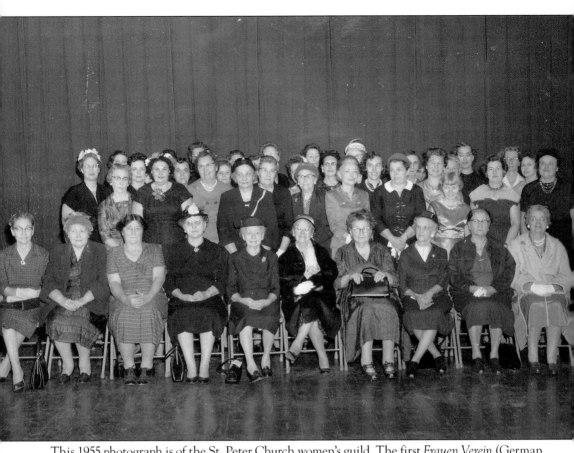

This 1955 photograph is of the St. Peter Church women's guild. The first *Frauen Verein* (German for women's guild) was established in 1898. (Courtesy St. Peter Church.)

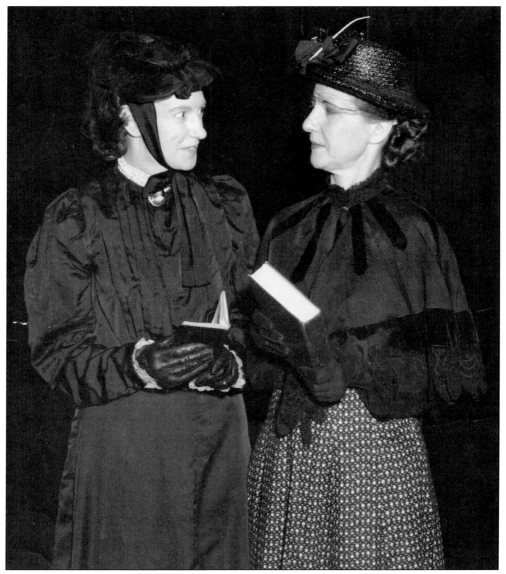

In the 1950s, the women's guild sponsored a talent hour, featuring three-act plays and skits. In this image, Alceste Cerwinske (left), informally known as "Al," and Dorothy Koehn portray characters in *Arsenic and Old Lace*. (Courtesy St. Peter Church.)

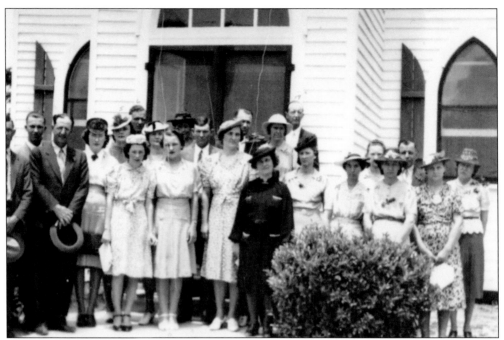

This early-1940s picture shows an adult confirmation class. Some of the early Spring Branch families represented here include the Kuhlmans, Telschows, Dilleys, Bangs, Eutons, Silbers, Yarbroughs, Oberprillers, Hillendahls, Reicherts, Ackermans, Sauers, Groschkes, Sittes, and Reicters. (Courtesy St. Peter Church.)

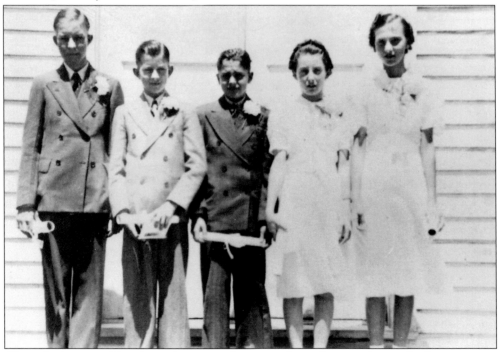

The 1939 St. Peter Church confirmation class poses for a photograph outside the sanctuary. (Courtesy St. Peter Church.)

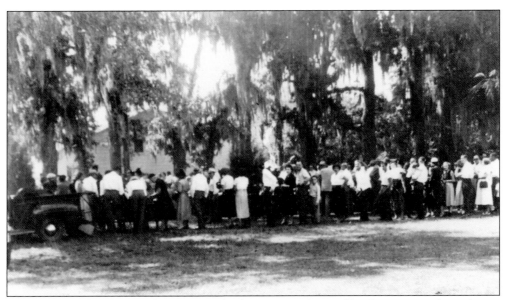

The St. Peter Church annual anniversary barbecue menu featured beef, sausage, and sauerkraut. Chicken, however, was not on the menu because it was not smoked like the other meats. (Courtesy St. Peter Church.)

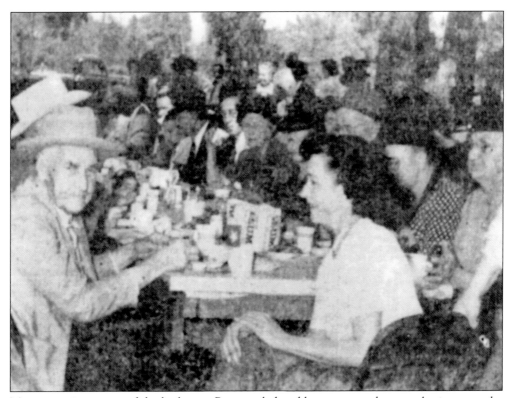

Meats were just a part of the barbecue. Potato salad and beans were other popular items on the menu. (Courtesy St. Peter Church.)

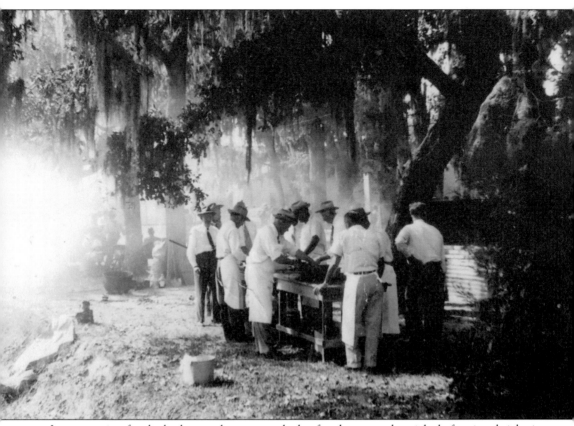

In preparation for the barbecue, the men smoke beef and sausage the night before in a brick pit. The barbecue pit was removed when the new sanctuary was built. (Courtesy St. Peter Church.)

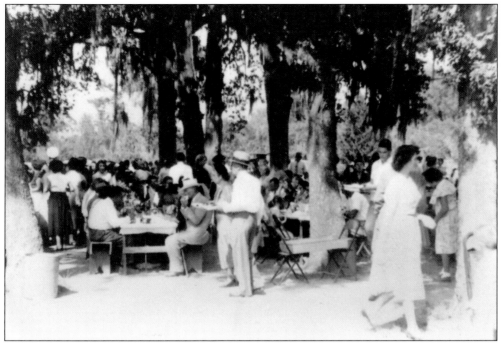

Families never came to the barbecue without a dish. Many brought desserts, such as strudels, cookies, cakes, and pies. (Courtesy St. Peter Church.)

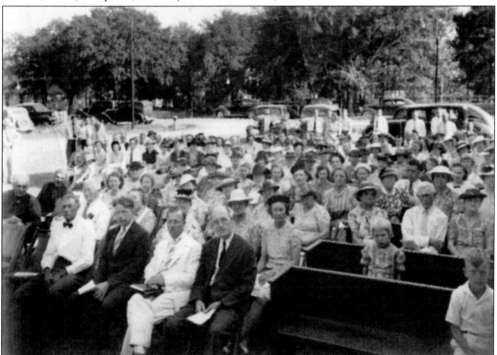

This photograph is of an outdoor service at St. Peter Church. Services were occasionally held outside, but in the days before air-conditioning, paper fans were passed out to the congregation for comfort regardless of the venue. (Courtesy Evelyn Schroeder Kingsbury.)

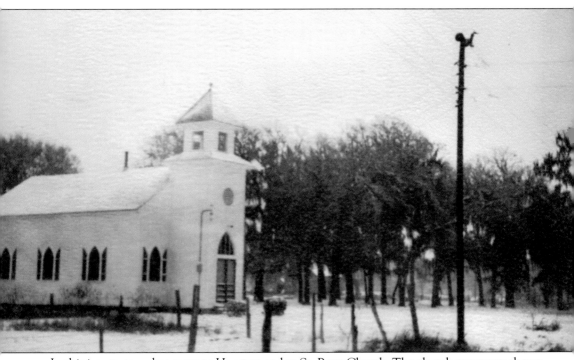

In this image, snow has come to Houston and to St. Peter Church. The church sanctuary shown here remains recognizable today, though snow is rare and the rural surroundings have long since been replaced with urban development. (Courtesy Barbara Telschow Beach.)

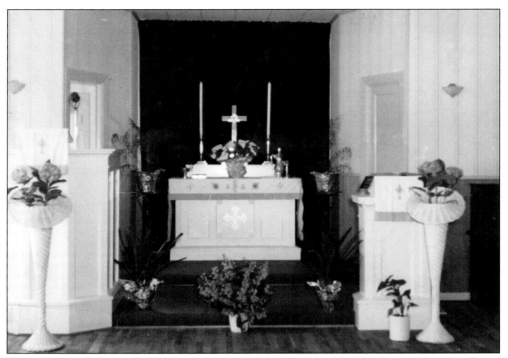

This photograph shows the altar at the original location of St. Mark Lutheran Church, at Long Point Road and Silber Road. (Courtesy Leonard and Joyce Vogt.)

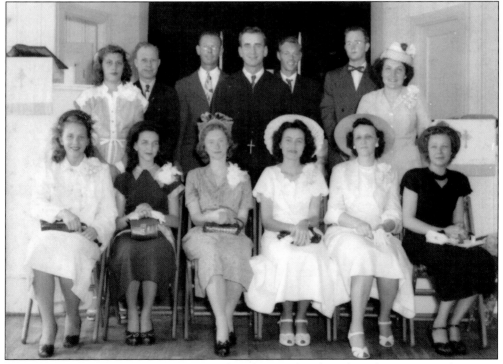

The first adult confirmation class at St. Mark Lutheran Church graduated in May 1949. (Courtesy Leonard and Joyce Vogt.)

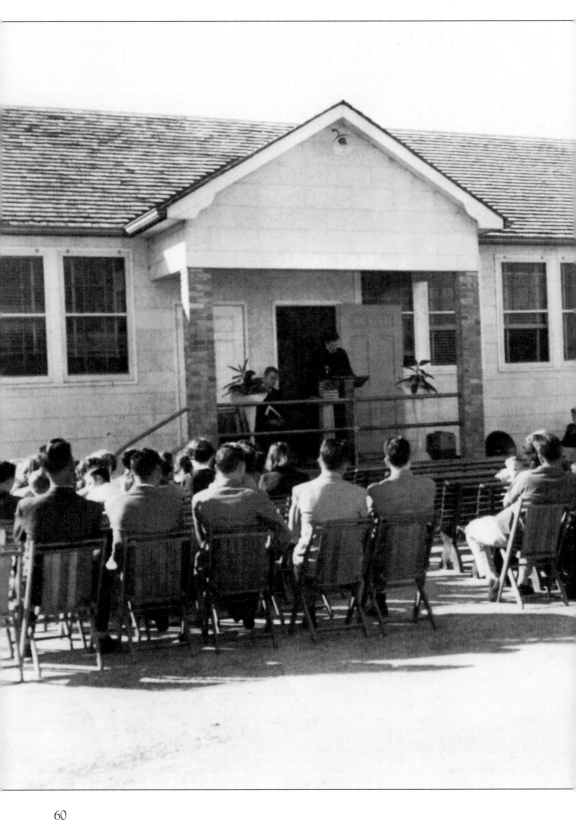

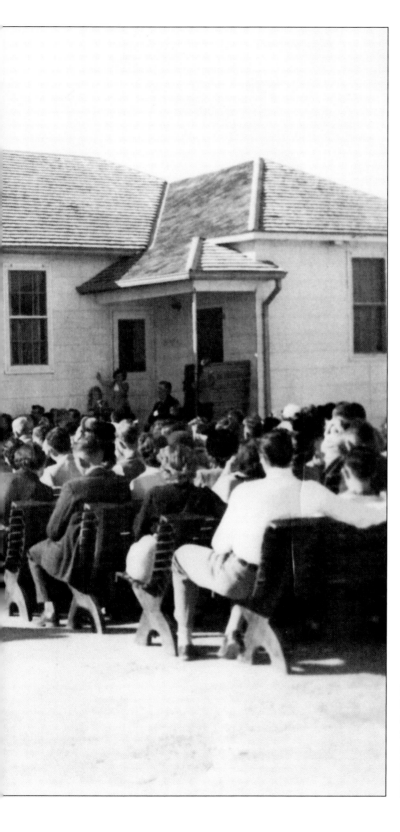

St. Mark Lutheran
Church congregants
meet outside before
moving the church to
a new, larger facility on
Hillendahl Boulevard.
(Courtesy St. Mark
Lutheran Church.)

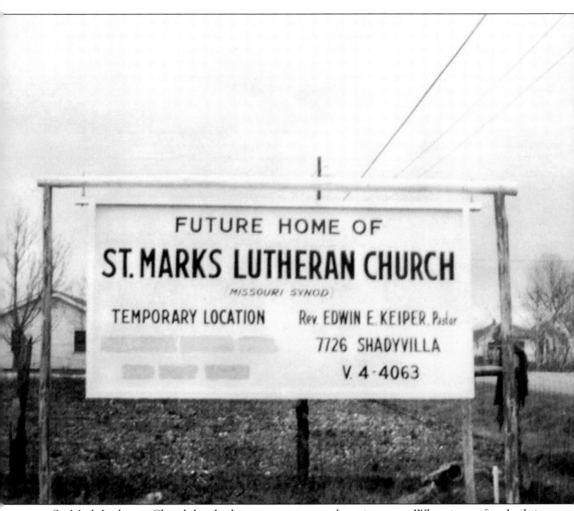

FUTURE HOME OF
ST. MARKS LUTHERAN CHURCH
(MISSOURI SYNOD)

TEMPORARY LOCATION Rev. EDWIN E. KEIPER, Pastor

7726 SHADYVILLA

V. 4-4063

St. Mark Lutheran Church has had some controversy about its name. When it was first built in 1949 at the intersection of Long Point and Silber Roads, it was named St. Mark's. Eventually, a new building was built on the same site, and its cornerstone read "St. Mark." When this discrepancy was noticed, the congregation was asked whether it preferred "St. Mark" or "St. Mark's." St. Mark won. However, this sign, which advertises the future (now present) location on Hillendahl Boulevard, reads differently. The present church and school are known as St. Mark, yet the cornerstone of the current church is inscribed "St. Mark's." (Courtesy St. Mark Lutheran Church.)

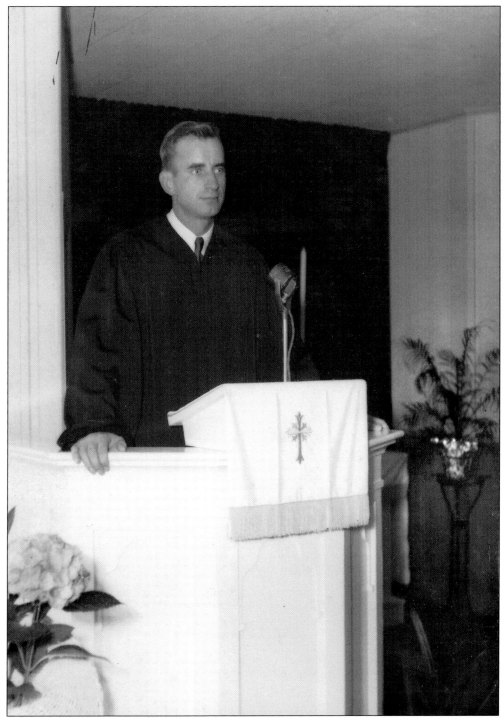

The Lutheran Church sent the Rev. Edwin E. Keiper to establish a mission in the Spring Branch area. Keiper was the original pastor of St. Mark Lutheran Church. (Courtesy Leonard and Joyce Vogt.)

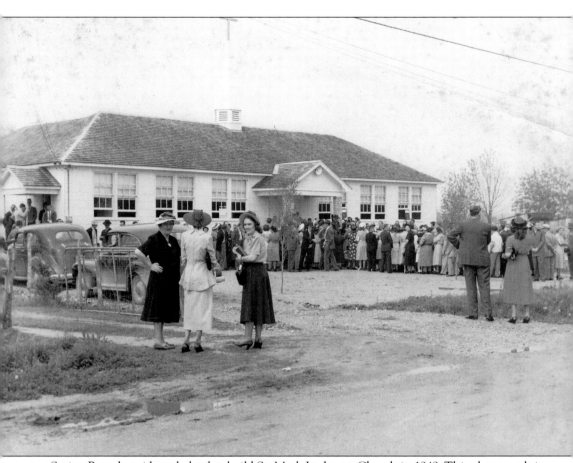

Spring Branch residents helped to build St. Mark Lutheran Church in 1949. This photograph is of the original church. The congregants built a second sanctuary on the site, at the intersection of Long Point and Silber Roads. Eventually, the church purchased a new lot and moved to its present location, on Hillendahl Boulevard, in 1959. (Courtesy Leonard and Joyce Vogt.)

Three

SCENES

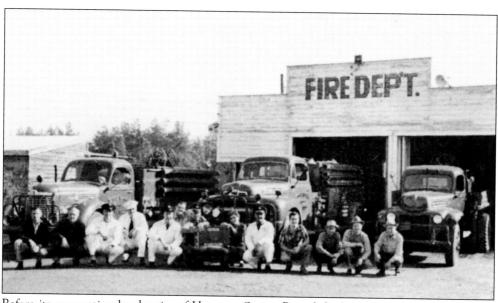

Before its annexation by the city of Houston, Spring Branch had a volunteer fire department. The station was located on the south side of Katy Road, near Campbell Road. According to the *Hedwig Village Gazette*, the department had a homemade fire truck. E.P. "Gene" O'Rourke served as the first fire chief. (Courtesy Evelyn Schroeder Kingsbury.)

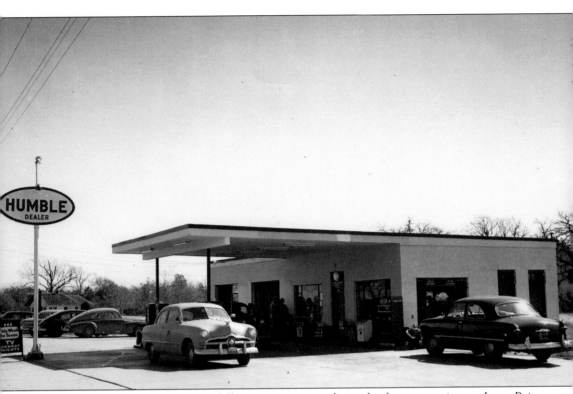

The Humble Gas Station was a full-service station and was the first gas station on Long Point Road. This photograph was taken in the late 1940s or early 1950s. In those days, Jack Valenti, who co-owned an advertising agency at the time, helped to promote the store. In 1963, Valenti became an aide to Pres. Lyndon B. Johnson and, later, served as president of the Motion Picture Association of America. (Courtesy Ruth Hillendahl Plumb.)

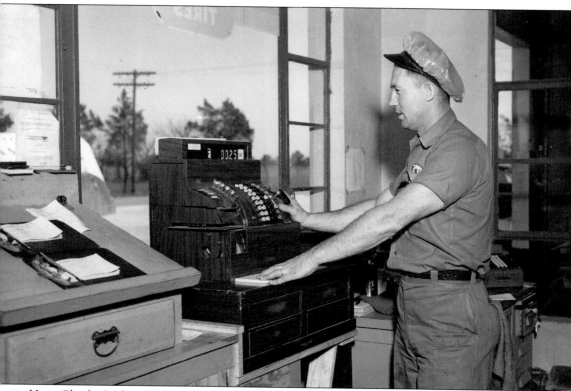

Here, Charles Melvin Wolfe works at the Humble (which later combined with Standard Oil of New Jersey to form Exxon) gas station. The station was located at 8115 Long Point Road, at the intersection with Monarch Oaks Street. Kerosene was 25¢ per gallon. A car wash and grease was $1.75. The station opened in 1949 and closed in the mid-1950s. Today, a used-car lot occupies the property. (Courtesy Ruth Hillendahl Plumb.)

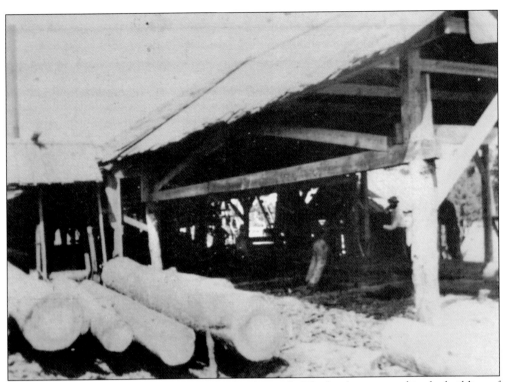

Many early Spring Branch settlers worked in lumberyards. The lumber was used in the building of local houses and businesses. The Bauer lumberyard shown here was one of several such enterprises that served the Spring Branch area. Other families who owned lumberyards included the Rummels and the Hildebrandts. (Courtesy Nelda Blackshere Reynolds.)

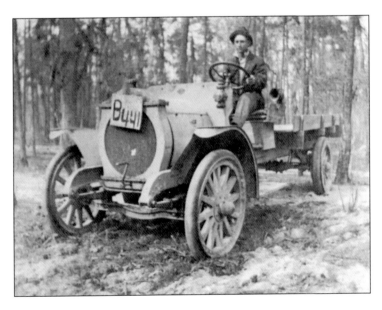

In this image, Ed Bauer sits in an early Bauer lumberyard company truck long before paved roads came to the Spring Branch area. Lumber was loaded into the back of the truck and delivered to construction sites. Note the early license plate. (Courtesy Nelda Blackshere Reynolds.)

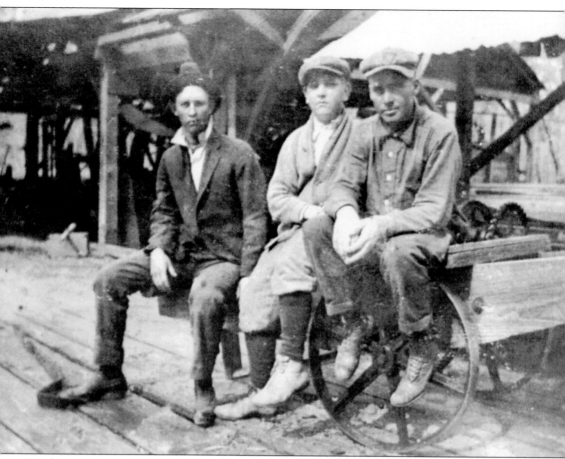

Workers at the Bauer lumberyard take a break from their duties. (Courtesy Nelda Blackshere Reynolds.)

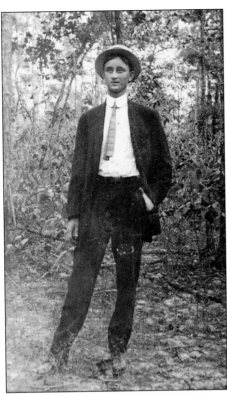

This photograph shows Albert Bauer, of the Bauer lumberyard. The business expanded into different areas as Spring Branch grew and people settled in other western areas of Harris County. (Courtesy Nelda Blackshere Reynolds.)

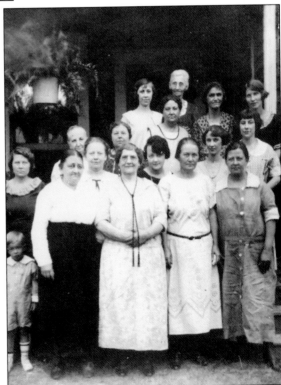

In groups like the Spring Branch Sewing Club, quilting, crocheting, knitting, and tatting were popular social activities for ladies in the Spring Branch area. (Courtesy Nelda Blackshere Reynolds.)

The back of a receipt from the Beinhorn store thanks the customer for his or her business. The building in which the store was headquartered still exists, though the business itself has long been shuttered. The family spoke German in their home, which was above the shop, but English was used in the store. (Courtesy Bill Pielop.)

AN AFTER-THOUGHT

You have been kind enough to favor us with your patronage today.

We appreciate the favor and desire only that you shall be perfectly satisfied. If, for any reason, you are not satisfied with any article you have purchased, we ask that you return the same and the matter will be adjusted to your entire satisfaction.

Houston Paper Co., Houston, Texas

Nº 36376

RESIDENT HUNTING LICENSE

NOT TRANSFERABLE

This is to certify that _W. A. Beinhorn_

whose age is _45_, height _6ft_, weight _183_, color of hair _Brown_, eyes _blue_, and whose post-office is _Houston_, county of _Harris_, having paid the license fee of $2.00 is hereby licensed to hunt and kill game during the open season therefor in all counties in the State of Texas, subject to all the provisions and penalties provided for by the game laws of this State.

Dated at _Houston_, this _25th_ day of _Nov_, 19__

Nº 36376 W. W. BOYD, Game, Fish and Oyster Commissioner of Texas.

By _Texas Sporting Goods Co. Inc_

Expires August 31, 1925. (County Clerk) or Game Warden.
W. W. BOYD,
Game, Fish and Oyster Commissioner of Texas.

I hereby certify that I am a citizen of Texas and promise that I will not exceed in one day the bag limit as set forth on reverse side of this license.

W. A. Beinhorn

This license must be carried on person when hunting and upon demand must be exhibited for inspection by any Game Warden or peace officer.

Form 409b-M230-524-100m

REPORT OF GAME KILLED SEASON 1924-25

No. Deer ____ killed in _____ County
No. Turkey ____ killed in _____ County
Quail _____ Doves _____ Geese _____
Prairie Chicken ____ Plover ____ Ducks _____
Other game _____ Other Game Killed (Give number of each) _____ County, Texas
Signed _____

(Over)

This 1924–1925 hunting license was issued to Will Beinhorn by the State of Texas. Beinhorn hunted rabbits in the unincorporated Spring Branch area, which did not require a license. However, he did need this license for deer hunting, which he did elsewhere. The license expired on August 31, 1925. (Courtesy Bill Pielop.)

Barbara Telschow, front left, poses with, from left, Fannie Tucker, Ike Telschow, and Donnie Telschow on Witte Road in 1946. Tucker is the mother of Donnie Telschow, the mother-in-law of Ike Telschow, and grandmother of Barbara Telschow. The family is facing north in this photograph. Witte Road today has subdivisions on either side as one drives south towards Haden Park and the Long Point Road intersection. (Courtesy Barbara Telschow Beach.)

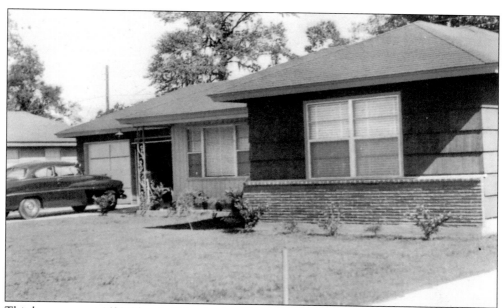

This house was at 1630 Glourie Drive in the Glenmore Forest subdivision, between Long Point Road, Westview Road, Wirt Road, and Pine Chase Drive. The addition was built by Roy Bracher Construction in the early 1950s. Bracher started building homes in Spring Branch after returning from military service in both World War II and the Korean War. The Timber Creek subdivision has a Bracher Park named in his honor. (Courtesy Nelda Blackshere Reynolds.)

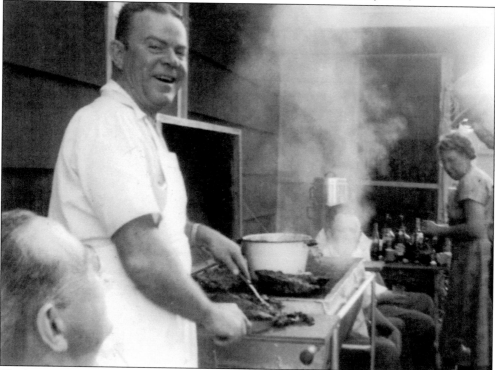

The house on Glourie Drive was the setting for many family and neighborhood barbecues. Bob Blackshere was a genial host on these occasions. (Courtesy Nelda Blackshere Reynolds.)

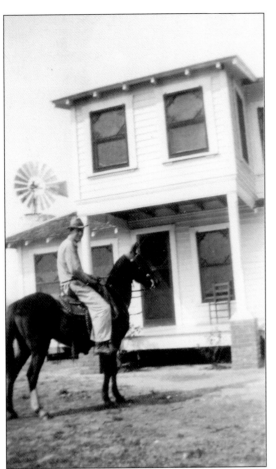

In the days before automobiles and paved roads, many Spring Branch residents rode horses to get around. (Courtesy Nelda Blackshere Reynolds.)

The house at 9602 Long Point Road was built for Otto and Eva Vogt in 1950. The Vogts purchased the lot before World War II in hopes of returning to the Spring Branch area from the Heights, as Eva was a third-generation Kolbe-Beinhorn family descendent. Construction on the home began after the war, and the small farmhouse at the back of the lot became a home for Eva's mother, Bertha Beinhorn-Kolbe. The Vogts had a small fishing pond, chicken coop, storage barns, cattle pasture, and garden on this lot as well. The oak trees were the setting for children's games, such as hide-and-seek. The lot was sold and the house was torn down. (Courtesy Nelda Blackshere Reynolds.)

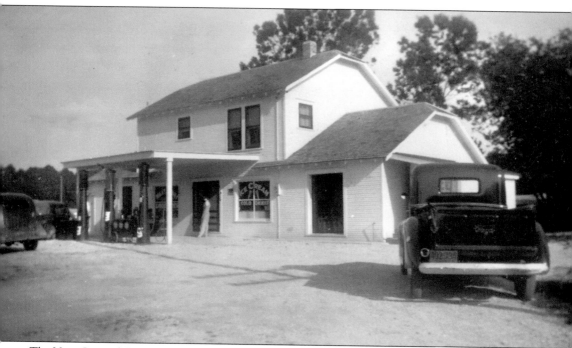

The Vogt General Store was located on Katy Freeway, east of Campbell Road, near the present-day locations of Carter's Country and Goode Company Barbeque. The store sold gas and oil, groceries, meats, all types of livestock feed, hand-packed ice cream, blocks of ice, and light hardware. The 50-pound ice blocks were placed on car bumpers, and the ice would melt onto the bumper and could be transported easily. This is the second store the Vogts built at this site. The Vogt family lived on the second floor. (Courtesy Leonard and Joyce Vogt.)

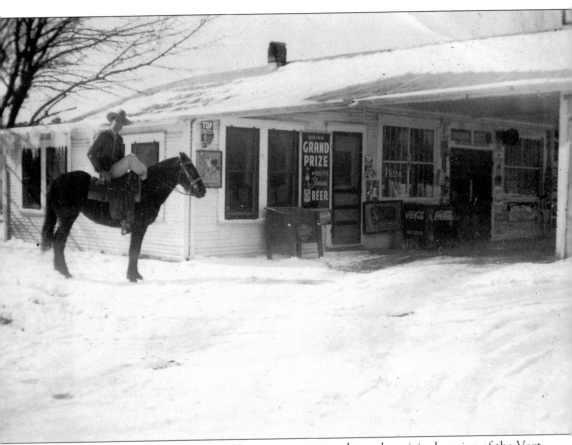

This 1939 image, taken after a rare Houston snowstorm, shows the original version of the Vogt General Store on the Katy Freeway. Directly behind the man on horseback is a bar. The Vogt family lived in a set of rooms in back of the store before deciding to tear down this structure and put up a two-story building. (Courtesy Leonard and Joyce Vogt.)

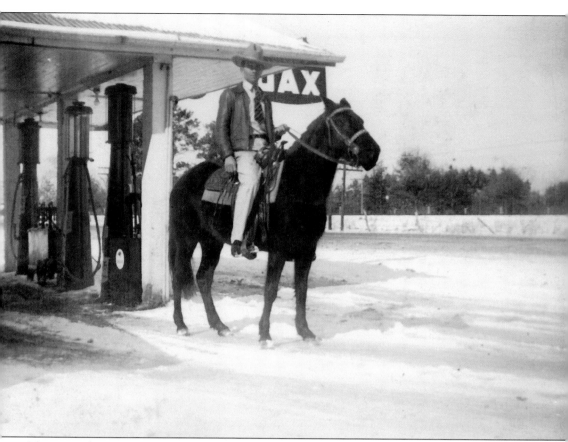

This is another photograph taken after the 1939 snowstorm. Jax (the sign in front of the store) was a popular beer in its day. Customers could enjoy a beer while their grocery list was being filled and meat prepared. In those days, one could purchase a beer at the bar and go into the grocery store to visit with fellow shoppers and grocery store staff. Customers could purchase a 24-bottle case of beer, but not a six-pack, as this was in the days before six-packs or aluminum cans. (Courtesy Leonard and Joyce Vogt.)

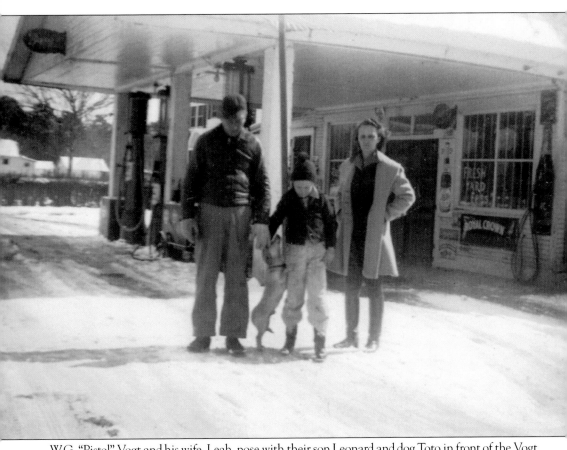

W.G. "Pistol" Vogt and his wife, Leah, pose with their son Leonard and dog Toto in front of the Vogt General Store. Pistol Vogt moved his family from the Addicks area (near today's Eldridge Parkway) in 1935 and rented the store from the Riedel family. (Courtesy Leonard and Joyce Vogt.)

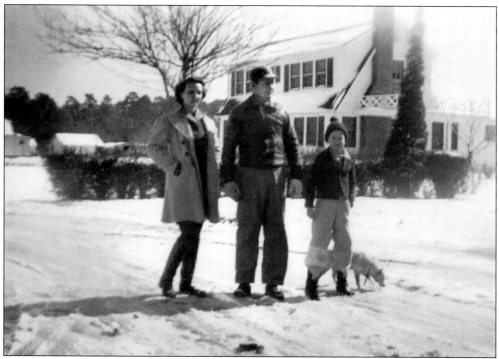

The family poses here in front of the Riedel house, which was on the east side of the Vogt General Store. The Vogts lived in a set of rooms in the back of the store. (Courtesy Leonard and Joyce Vogt.)

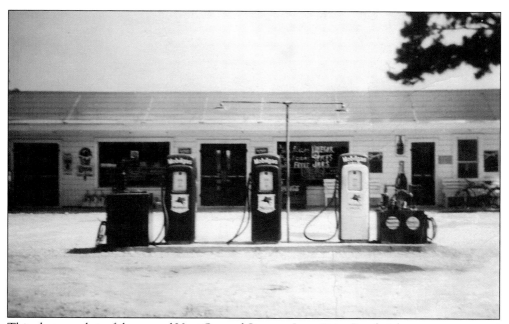

This photograph is of the second Vogt General Store on Long Point Road. A kerosene pump, used for stoves and, in some cases, lamps, is on the far left. Old pumps are on the far right. (Courtesy Leonard and Joyce Vogt.)

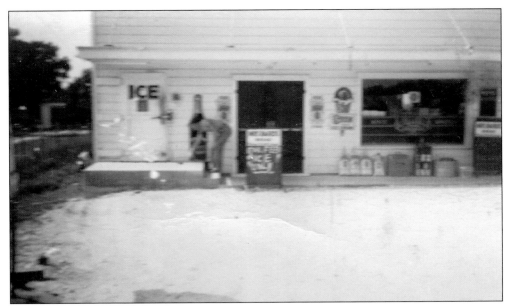

Leonard Vogt used tongs to pick up the ice blocks and place them on the bumpers of customers' cars for transport. The feed and ice were on one side of the Vogt General Store, and the refrigerated items, groceries, and meats were in the middle of the store. (Courtesy Leonard and Joyce Vogt.)

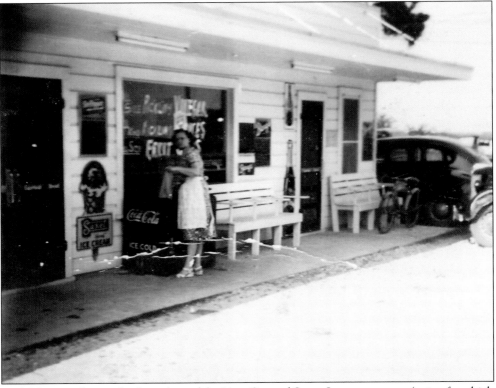

Leah Vogt stands near the front door of the Vogt General Store. Ice cream cones (a sign for which can be seen next to the door) were among the popular items available for purchase. (Courtesy Leonard and Joyce Vogt.)

Relatives and friends stopped by during the opening days of the second location of a Vogt General Store, on Long Point Road east of Antone Road. This photograph was taken in October 1948. (Courtesy Leonard and Joyce Vogt.)

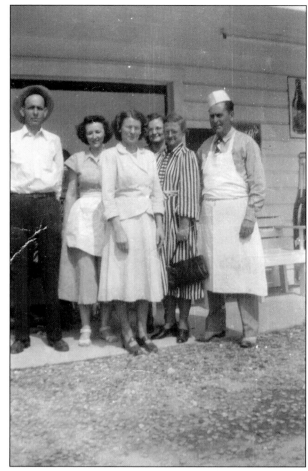

Joyce Mitschke and her parents were frequent customers at the Vogt General Store on Long Point Road. The house where she was raised, shown here, was four blocks from the store. Joyce and Leonard Vogt married in April 1961. (Courtesy Leonard and Joyce Vogt.)

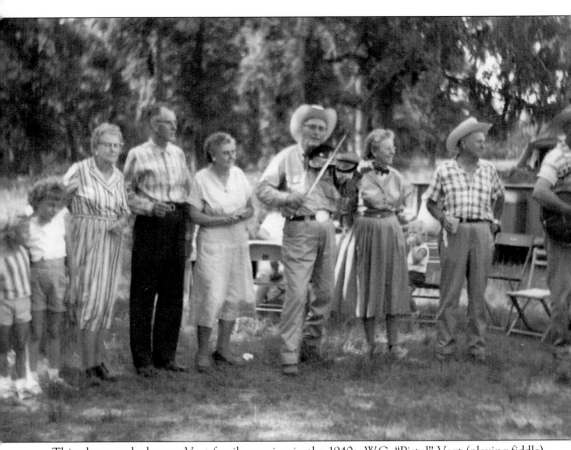

This photograph shows a Vogt family reunion in the 1940s. W.G. "Pistol" Vogt (playing fiddle) was considered the jokester at these events. Buddy Smith, at far right, played the guitar. (Courtesy Leonard and Joyce Vogt.)

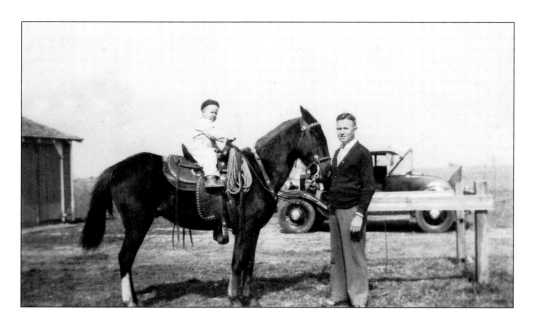

In the above photograph, young Leonard Vogt learns the ropes, when it comes to riding a horse, from Bob Blackshere. Many Spring Branch residents had horses on their farms even as automobiles were becoming the preferred way to get around the area. In the image below, Pistol Vogt poses with his nephew on a sulky, a lightweight cart having two wheels. Sulkies were used for tasks involving logging, plowing, and cultivating or, in this case, as a light stroller. (Both, courtesy Leonard and Joyce Vogt.)

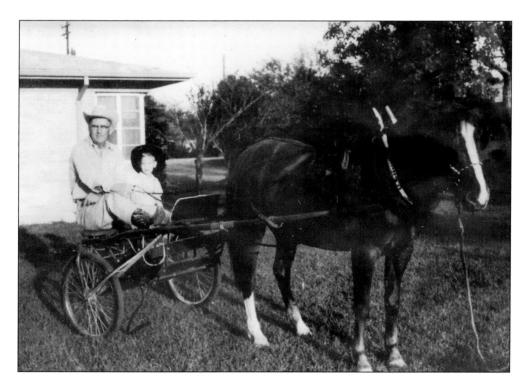

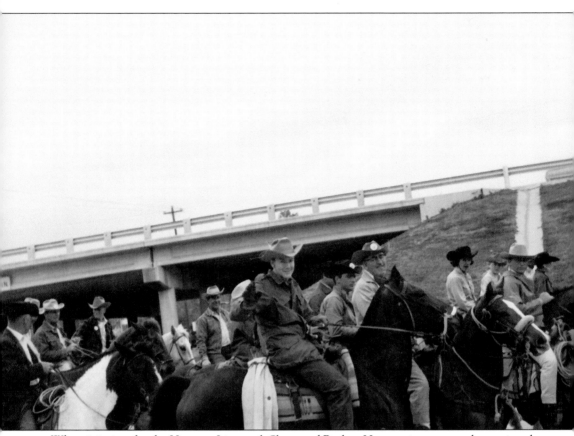

When it is time for the Houston Livestock Show and Rodeo, Houstonians are used to seeing the trail riders come through Spring Branch and under Loop 610 (in the background) to Memorial Park in preparation for the annual rodeo parade through downtown Houston. (Courtesy Leonard and Joyce Vogt.)

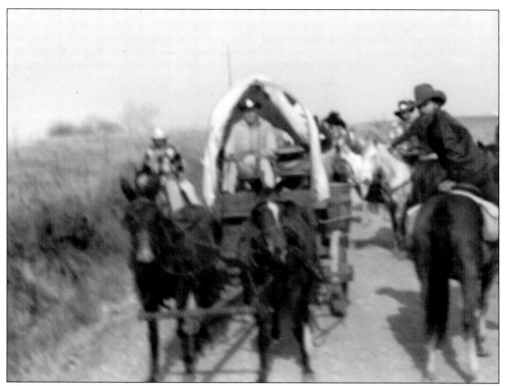

Chuck wagons, such as this one, carried food and cooking supplies for the riders on the Salt Grass Trail Ride. The trail ride, which began in 1952, is scheduled to precede and promote the Houston Livestock Show and Rodeo. The rodeo, originally called the Houston Fat Stock Show and Livestock Exposition, began in 1932. (Courtesy Leonard and Joyce Vogt.)

Foods carried on chuck wagons were easy-to-fix fare, including beans, breads, coffee, and meats. According to the American Chuck Wagon Association, chuck wagons served as a "home away from home" for cowboys on the trail and carried sleeping gear and other supplies in addition to food. (Courtesy Leonard and Joyce Vogt.)

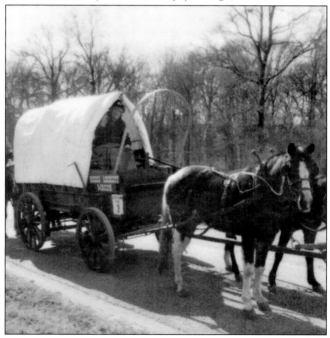

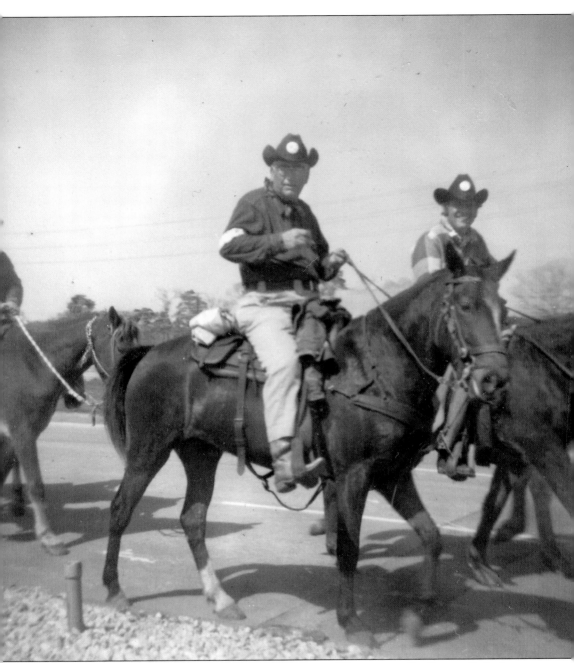

The Salt Grass Trail Ride begins about 65 miles west of Houston, in Cat Spring. Only four men made the first ride in 1952 from Brenham to Houston. The following year, 80 people signed up, and the ridership has increased steadily since that time. The Salt Grass Trail Ride was one of 13 trail rides that came into Houston for the 2011 rodeo. (Courtesy Leonard and Joyce Vogt.)

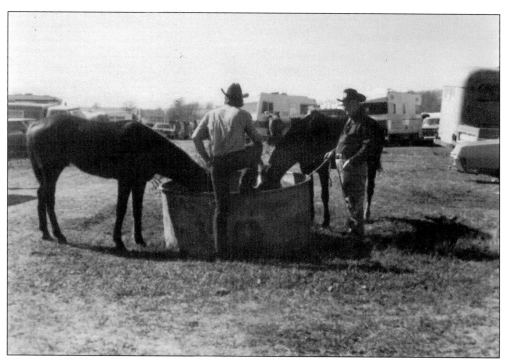

Taking good care of the horses remains an important part of a successful trail ride. Organizers see to it that food and water are ready for the horses at the appropriate stops. (Courtesy Leonard and Joyce Vogt.)

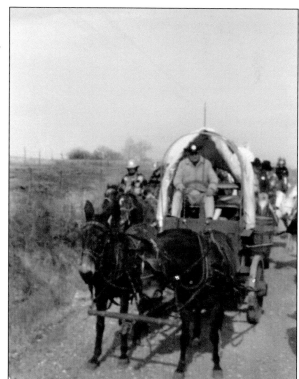

Most, but not all, of the trails to Houston come from the north or west. The Northeastern Trail Ride, for example, runs westward from Beaumont to Houston. Another trail, the Spanish Trail Ride, comes from Coldspring, to the northeast. (Courtesy Leonard and Joyce Vogt.)

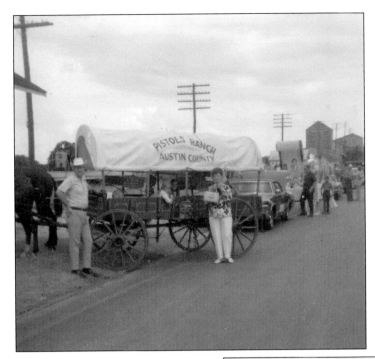

A wagon with some young passengers advertises Pistol Vogt's Ranch in Austin County, which is west of Houston and Harris County. Then, as now, children get involved with the trail rides at an early age and continue their interest and participation into adulthood. (Courtesy Leonard and Joyce Vogt.)

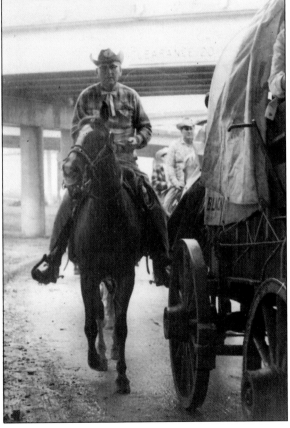

The Salt Grass Trail riders, along with riders from other trails, enter Memorial Park to spend the night before participating in the rodeo kickoff parade the next day, a practice that continues today. Loop 610 is visible in the background of this picture. (Courtesy Leonard and Joyce Vogt.)

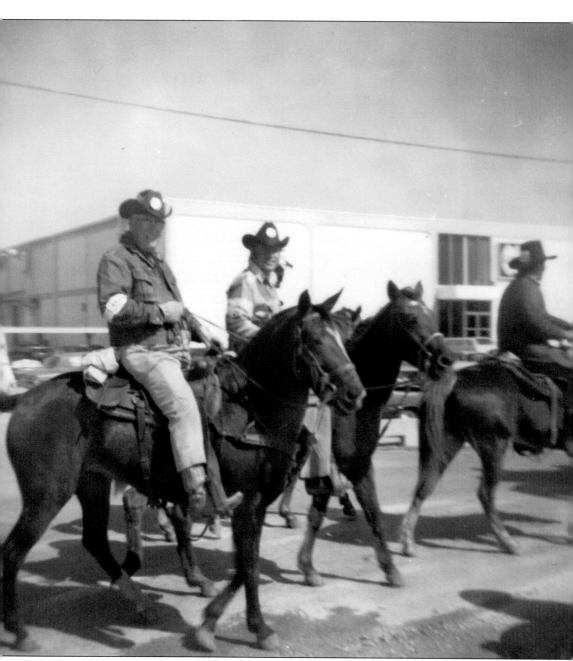

W.G. "Pistol" Vogt was a regular rider on the Salt Grass Trail Ride. On the day of his burial, the participants in the Salt Grass Trail Ride happened to be passing by Memorial Oaks Cemetery, which was along the trail route, when the funeral was taking place. Some of Vogt's friends left the caravan to attend the graveside service. (Courtesy Leonard and Joyce Vogt.)

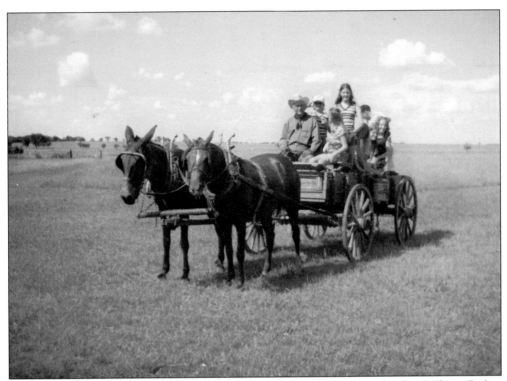

W.G. "Pistol" Vogt poses with some children enjoying a wagon ride on his family farm. Before the city of Houston grew westward and the area became urbanized, Spring Branch was primarily farmland. (Courtesy Leonard and Joyce Vogt.)

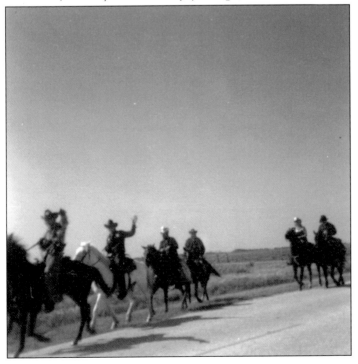

The trail ride began as an opportunity to promote the rodeo but has now become an institution in itself, giving modern-day Texans a chance to relive the past. Waving at passersby in automobiles is nothing new for today's trail riders. (Courtesy Leonard and Joyce Vogt.)

Po Mac's Hamburgers, located at Piney Point Road and the Katy Freeway, was a popular hangout in its day. But, like many other restaurants, it eventually closed and the property on which it sat was redeveloped. (Courtesy Steve Griffin, HoustonHistory.com.)

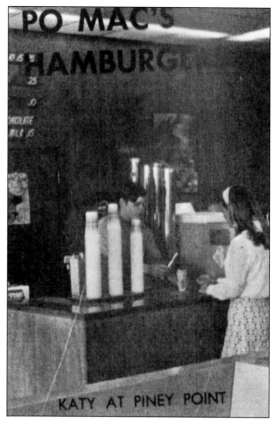

KATY AT PINEY POINT

In addition to the *Houston Chronicle* and the now defunct *Houston Post*, newspaper readers in Spring Branch could read the weekly *West Side Reporter*, which focused on news involving the Spring Branch area, including Bunker Hill Village, Hedwig Village, Hillshire Village, Hunters Creek Village, Piney Point Village, and Spring Valley. Both the *Post* and the *Reporter* no longer exist. Meanwhile, the *Chronicle* features neighborhood sections, including one focused on the Spring Branch–Memorial area, in its Thursday editions. (Courtesy Steve Griffin, HoustonHistory.com.)

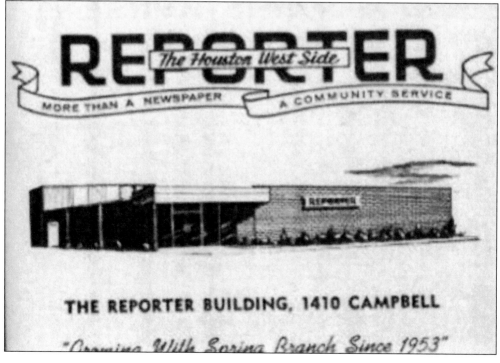

THE REPORTER BUILDING, 1410 CAMPBELL

"Growing With Spring Branch Since 1953"

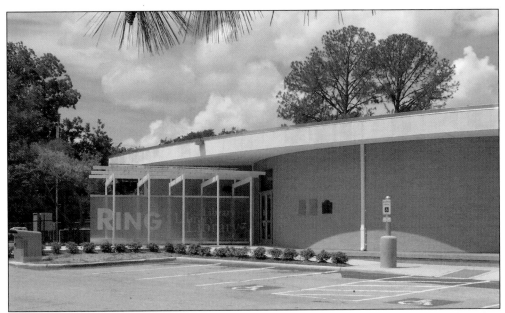

Elizabeth Ring was a longtime Houston Public Library Board member who joined the board in 1900 and served for 41 years. In 1964, the City of Houston dedicated a library in her name. The Ring Neighborhood Library is on Long Point Road, east of St. Peter Church. The library recently underwent renovation and reopened in 2010. (Photograph by George Slaughter.)

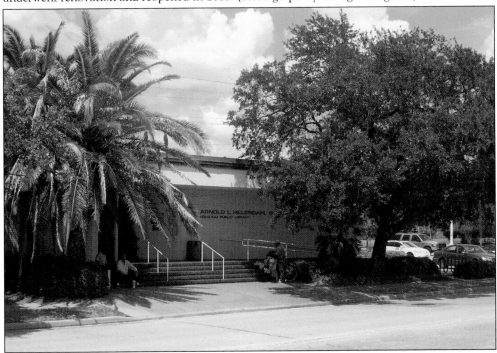

The Arnold L. Hillendahl branch of the Houston Public Library, on Emnora Lane at Gessner Road, honors Arnold Louis Hillendahl. The Hillendahl Library and Elizabeth Ring Library, on Long Point Road, are the two city-owned public libraries in Spring Branch. (Photograph by George Slaughter.)

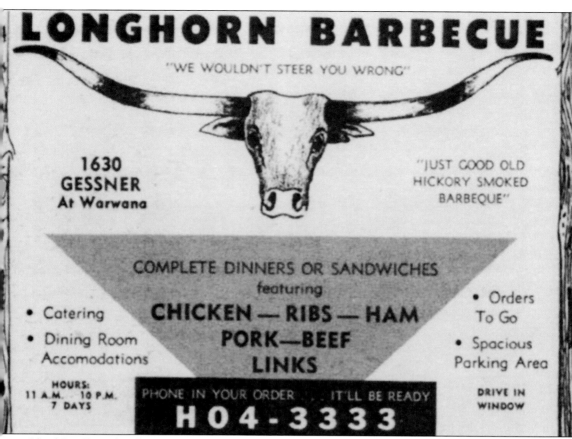

Lloyd Smallwood and Leonard McNeill's Longhorn Barbecue, on Gessner Road, was one of many restaurants that served the people of Spring Branch. Longhorn Barbecue eventually went out of business and today a taqueria stands on the site. (Courtesy Steve Griffin, HoustonHistory.com.)

Barbara Telschow sits with the family dog in front of the Telschow farm smokehouse. Farms had smokehouses for curing and storing meats. Often, the structures were secured to protect the meat from animals and/or thieves. (Courtesy Barbara Telschow Beach.)

Henry Sledge poses for a portrait at the Telschow farm. The property was eventually sold and developed, and today a subdivision and strip mall are on the farm site. (Courtesy Barbara Telschow Beach.)

Four

SCHOOLS

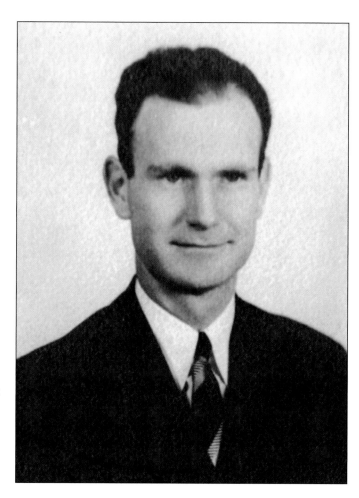

H.M. Landrum, shown here in 1940 during his service as Addicks High School principal, was later a longtime superintendent of the Spring Branch Independent School District. The Landrum Middle School, at 2200 Ridgecrest Drive, was named in his honor. (Courtesy Ruth Hillendahl Plumb.)

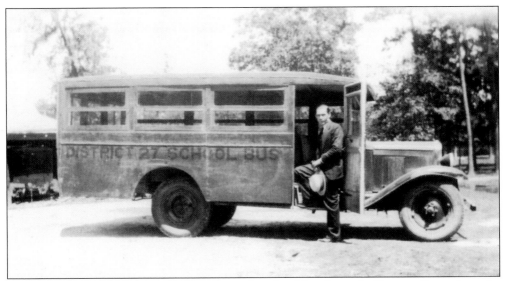

This 1920 photograph of James Warenberger, the school bus driver for District 27, predates the Spring Branch Independent School District. The District 27 era was long before the existence of paved roads or the subdivisions that dominate the Spring Branch area today. (Courtesy Nelda Blackshere Reynolds.)

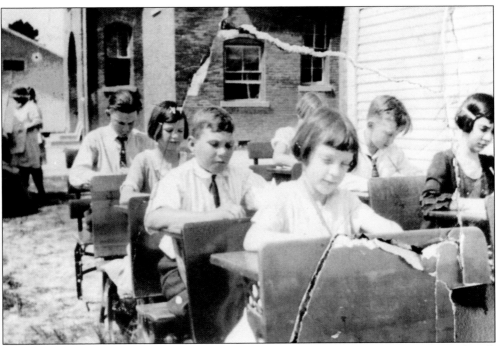

In this undated photograph, students do their work in an outdoor setting. St. Peter Church constructed its first educational building in 1939, thanks in part to a loan from the First Evangelical Church. Note the style of the times, with boys wearing ties to school. (Courtesy Nelda Blackshere Reynolds.)

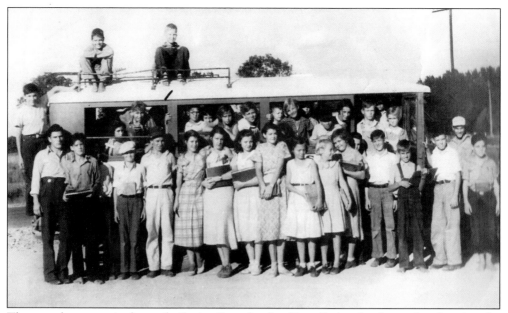

These students pose in front of a Spring Branch school bus. Early school records referred to the school district as District 27, which extended to the Addicks community, near the present-day intersection of I-10 and State Highway 6. Eventually, the school district boundaries receded to the east, and it became the Spring Branch Independent School District. (Courtesy Ruth Hillendahl Plumb.)

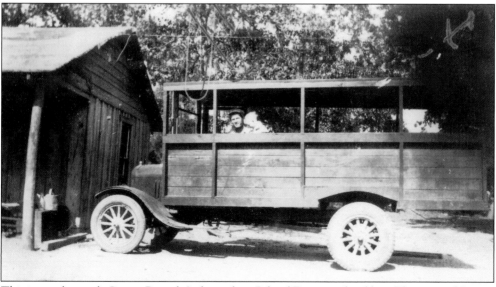

This is another early Spring Branch Independent School District school bus. The original Spring Branch School was located at the intersection of Campbell and Long Point Roads, and as the Spring Branch Independent School District evolved, the site became the location of Spring Branch Elementary School. (Courtesy Ruth Hillendahl Plumb.)

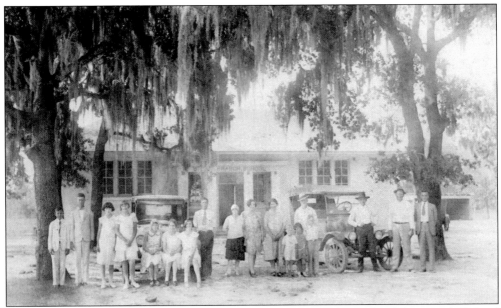

Students and faculty pose in front of the Spring Branch School in this undated photograph. Behind the school stood a precursor to a present-day convenience store, where students could purchase sandwiches, candy, chips, or similar snacks once a week. (Courtesy Ruth Hillendahl Plumb.)

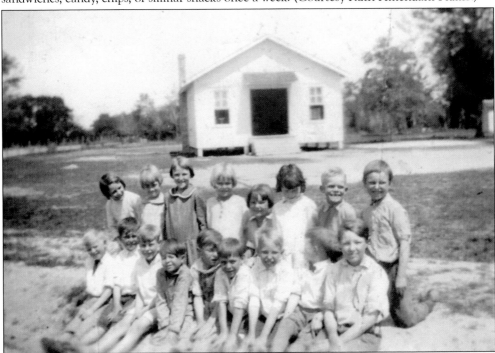

Students pose in front of the Spring Branch School. During the summers, the students would attend this school and learn to read, write, and speak German. This building stood west of St. Peter Church. As the Spring Branch Independent School District evolved, the site became the location of Spring Branch Elementary School, which as of this writing has been torn down and was scheduled to be rebuilt as part of a bond issue. (Courtesy Ruth Hillendahl Plumb.)

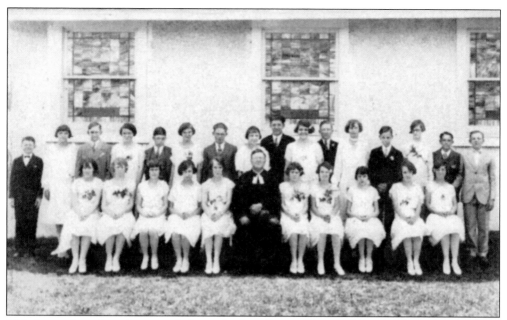

This image is a class photograph from the first Spring Branch School. The original school evolved into what is currently known as the Spring Branch Independent School District. In the top row, sixth from left, is Ida Schroeder, granddaughter of Jacob Schroeder. (Courtesy Evelyn Schroeder Kingsbury.)

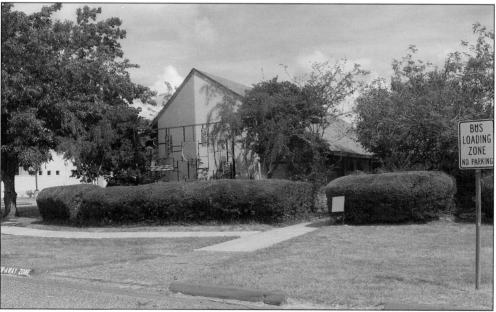

The Robert A. Vines Environmental and Science Center, located on Westview Drive, looks like a church because it was once the Spring Branch Church of the Nazarene. In 1967, the Spring Branch Independent School District purchased the building, which was vacant at the time, and converted it into a science center. Robert A. Vines was a longtime science teacher at Spring Branch High School. He also served as director of the Houston Arboretum and Botanical Garden. (Photograph by Kathy Rioux.)

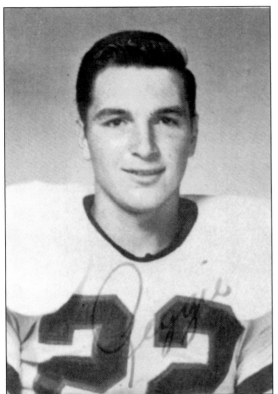

Reggie Grob was a Spring Branch High School football player who graduated in 1961 and went on to play at the University of Texas. Grob died from heat stroke during a September 1962 football practice at the university. The Spring Branch Independent School District (SBISD) named Grob Stadium in his honor. (Photograph from Spring Branch *Bruin* yearbook, courtesy Terry Tully Ondriska.)

Reggie Grob Stadium, located behind the Spring Branch Education Center, was once the prime venue for SBISD football games. Following the construction of Darrell Tully Stadium, Grob Stadium was reconfigured, and capacity was reduced. It remains in use for soccer and sub-varsity football games. Spring Branch High School alumni hold all-class reunions and use the stadium for flag football games against alumni teams from the other district high schools. (Photograph by George Slaughter.)

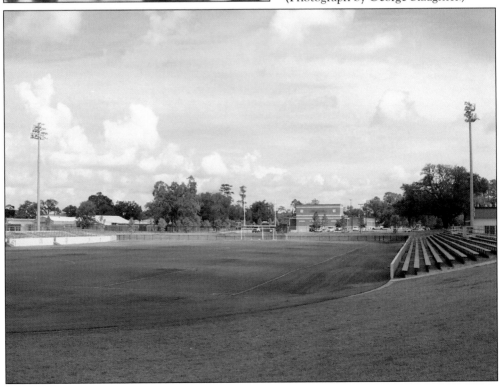

Tully Helps Lions Beat Chicago 10-0

Passes by Darrell Tully of East-
land paved the way Sunday for a
victory of the Detroit Lions over
Chicago Bears by the score of 10
to 0 in a National Professional
Football League game Sunday wit-
nessed by 35,000 fans at Chicago.

Before he became a football coach, Darrell Tully played quarterback for the Detroit Lions of the NFL. Tully played for one season, in 1939, in which the Lions finished with six wins and five losses. In those days, the NFL received little national news coverage—and even less in Texas, which did not have a pro football team. (Courtesy Terry Tully Ondriska.)

A 1939 telegram sent from the Detroit Lions to Darrell Tully offers holiday wishes. Telegrams were a popular way to communicate cross-country before long-distance telephone service became more prevalent. (Image courtesy Terry Tully Ondriska.)

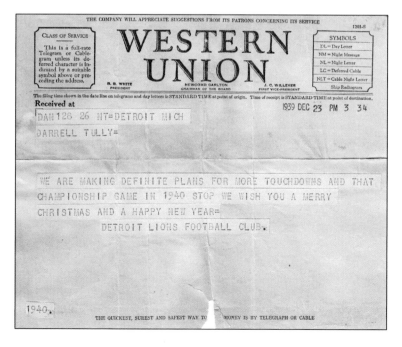

THE COMPANY WILL APPRECIATE SUGGESTIONS FROM ITS PATRONS CONCERNING ITS SERVICE

1201-S

WESTERN UNION

CLASS OF SERVICE

This is a full-rate Telegram or Cable-gram unless its de-ferred character is in-dicated by a suitable symbol above or pre-ceding the address.

SYMBOLS

DL = Day Letter
NM = Night Message
NL = Night Letter
LC = Deferred Cable
NLT = Cable Night Letter
Ship Radiogram

R. B. WHITE PRESIDENT NEWCOMB CARLTON CHAIRMAN OF THE BOARD J. C. WILLEVER FIRST VICE-PRESIDENT

The filing time shown in the date line on telegrams and day letters is STANDARD TIME at point of origin. Time of receipt is STANDARD TIME at point of destination.

Received at 1939 DEC 23 PM 3 34

DAN126 26 NT=DETROIT MICH

DARRELL TULLY=

WE ARE MAKING DEFINITE PLANS FOR MORE TOUCHDOWNS AND THAT
CHAMPIONSHIP GAME IN 1940 STOP WE WISH YOU A MERRY
CHRISTMAS AND A HAPPY NEW YEAR=
 DETROIT LIONS FOOTBALL CLUB.

1940.

THE QUICKEST, SUREST AND SAFEST WAY TO MONEY IS BY TELEGRAPH OR CABLE

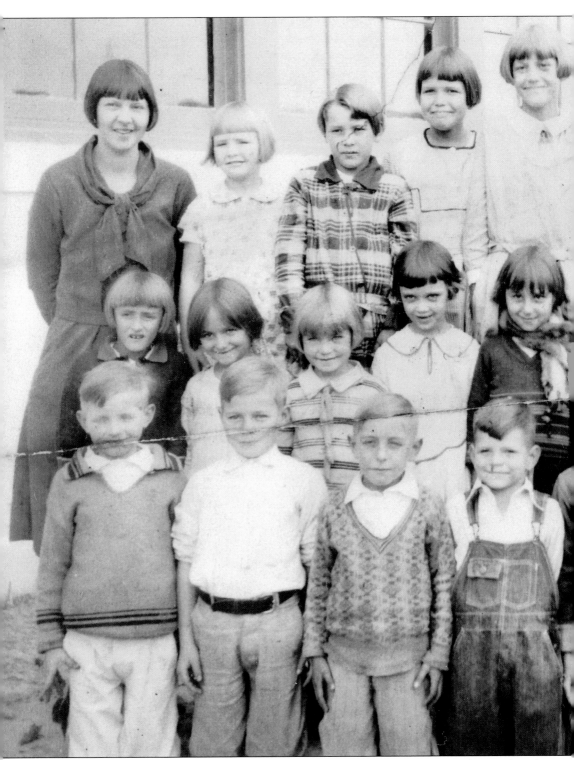

This 1930 class picture shows Inez Fluckinger (third row, far left), the first- and second-grade teacher at the Spring Branch School, and her students. The school eventually became Spring

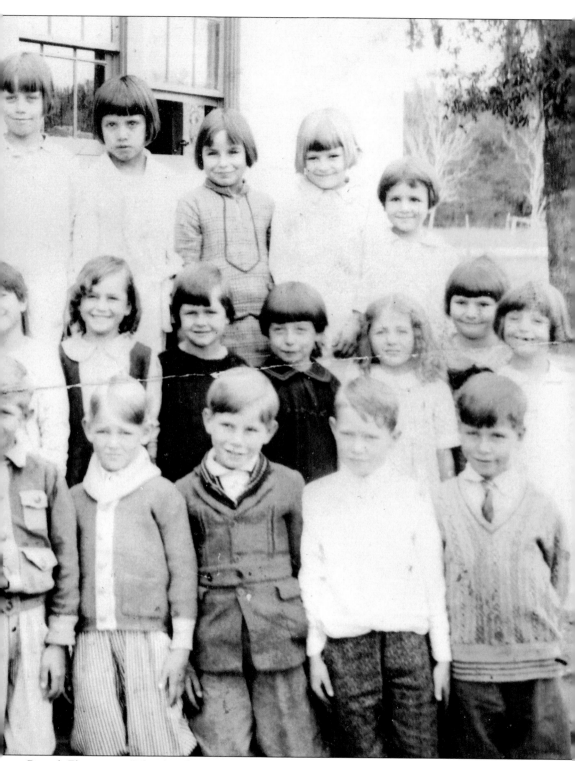

Branch Elementary School and remains at the intersection of Campbell and Long Point Roads. (Courtesy Doug Eschberger.)

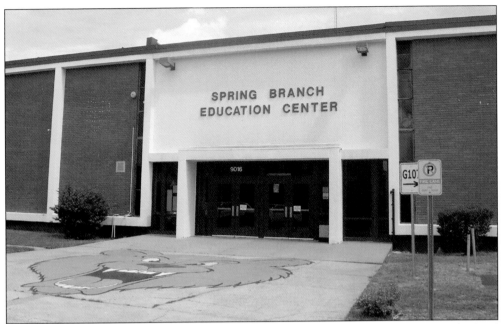

Spring Branch High School was the focal point of the Spring Branch Independent School District until the district opened five other high schools—Memorial, Spring Woods, Westchester, Northbrook, and Stratford. The district, citing declining enrollment, closed and repurposed Spring Branch and Westchester after the 1984–1985 school year. Spring Branch High School was converted into the Spring Branch Education Center, which houses the Spring Branch Academy of Choice. Westchester was converted into the Westchester Academy for International Studies. While Spring Branch High School no longer exists as such, the school spirit carries on, as shown by the bear icon painted in the foreground and by the Spring Branch High School Foundation Museum located behind the school. (Photograph by George Slaughter.)

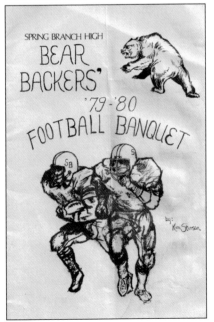

This is a program cover for the 1979–1980 Spring Branch Bears football banquet. Athletic booster clubs helped organize and stage honors banquets, where teams and players were recognized for the season's achievements. The Don Coleman Community Coliseum has hosted many banquets honoring Spring Branch teams over the years. (Courtesy Tom Plagens.)

Darrell Tully is pictured here with his wife, Edith Elaine Rosenquest Tully. They had two children, Dean and Terry. Edith was a physical education teacher in both the Galveston and Spring Branch School Districts. (Courtesy Terry Tully Ondriska.)

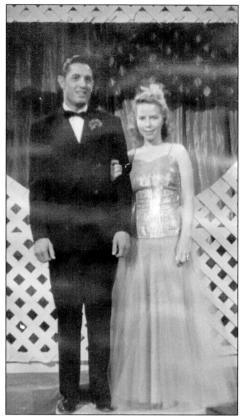

Darrell Tully poses with his wife, Edith Elaine Rosenquest Tully. The Tullys were childhood sweethearts in Eastland. Edith enjoyed playing golf with her husband and shared his interest in watching football, whatever teams were playing. (Courtesy Terry Tully Ondriska.)

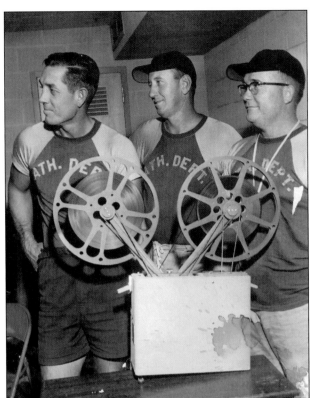

Coach Darrell Tully, left, watches game film with his assistant coaches. On the right is W.W. "Red" Emmons, who went on to serve as the first principal at Spring Woods High School. (Courtesy Terry Tully Ondriska.)

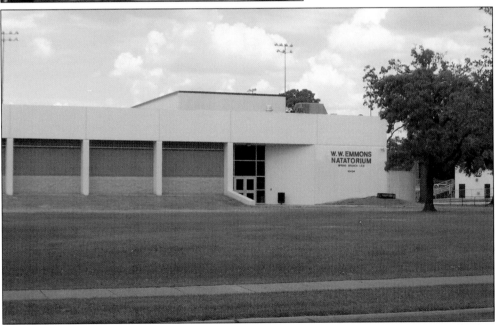

The school district built a natatorium and named it in honor of W.W. "Red" Emmons, the first principal at Spring Woods High School, after his retirement. The natatorium is on Tiger Trail, a short walk from the high school, and reopened in 2009 following a renovation. (Photograph by George Slaughter.)

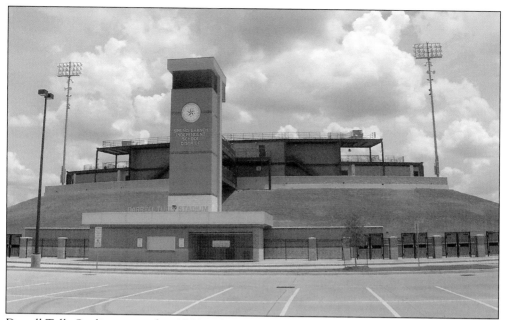

Darrell Tully Stadium opened in 1966 and seats 15,000 fans. It serves as the home venue for the four Spring Branch Independent School District high school teams—Memorial, Northbrook, Spring Woods, and Stratford—and seven middle school football and soccer teams. (Photograph by George Slaughter.)

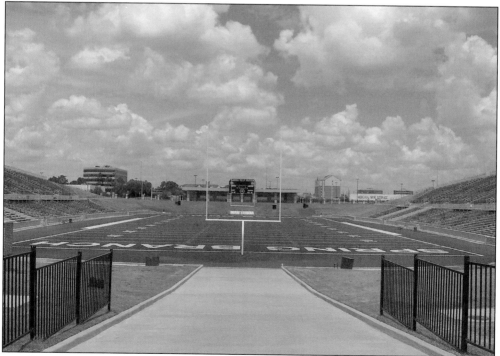

In addition to hosting football and soccer games involving district schools, Tully Stadium is regularly the site for high school play-off games. The stadium has also been used for graduation ceremonies. (Photograph by George Slaughter.)

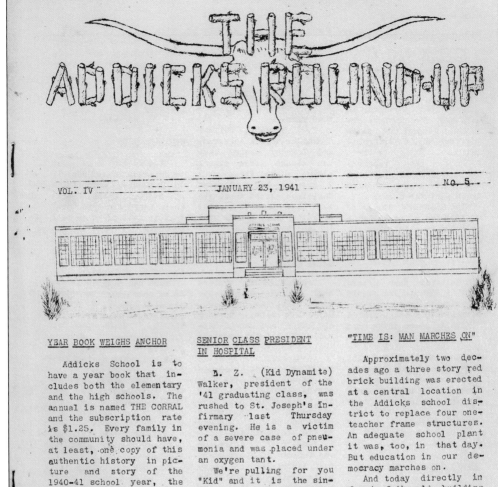

THE ADDICKS ROUND-UP

VOL. IV — JANUARY 23, 1941 — NO. 5

YEAR BOOK WEIGHS ANCHOR

Addicks School is to have a year book that includes both the elementary and the high schools. The annual is named THE CORRAL and the subscription rate is $1.25. Every family in the community should have, at least, one copy of this authentic history in picture and story of the 1940-41 school year, the first year in our new building.

The students of the journalism class are printing the publication which will be a combination of mimeographing, photography, lithographing, hard work, and fun.

This is the first year Addicks has undertaken to publish both school paper and a year book. Both are products of the journalism class.

SENIOR CLASS PRESIDENT IN HOSPITAL

L. Z. (Kid Dynamite) Walker, president of the '41 graduating class, was rushed to St. Joseph's Infirmary last Thursday evening. He is a victim of a severe case of pneumonia and was placed under an oxygen tant.

We're pulling for you "Kid" and it is the sincere wish of your senior class, the staff, faculty, and the entire student body that you have a very speedy recovery.

---:-----

CLASS ROOMS HEAR NATION'S 39th INAUGURAL CEREMONY

Monday at 10:30 the entire school listened intently to the 39th inaugural ceremony of the United States, over the school

(Cont'd on page 12)

"TIME IS: MAN MARCHES ON"

Approximately two decades ago a three story red brick building was erected at a central location in the Addicks school district to replace four one-teacher frame structures. An adequate school plant it was, too, in that day. But education in our democracy marches on.

And today directly in front of the old building stands one of the finest and most modernly equipped schools in this section of the state. Education here is marching on.

It is the sincere wish of the 1941 graduating class that Supt. H. E. Patton, the faculty, the present students, and all those students to come will progress and achieve as much in the future decades as in the past.

The *Addicks Round-Up* was an early student newspaper at Addicks High School. Students typed the pages in three columns, as shown here. After being created individually, the pages would be copied, stapled together, and distributed to the readership. This edition, from January 23, 1941, says that the students are "printing the publication, which will be a combination of mimeographing, photography, lithographing, hard work, and fun." This was the first year the students undertook both a student newspaper and a yearbook project. (Courtesy Doug Eschberger.)

The 1981 Spring Branch High School commencement program listed all the graduating seniors. The program cover, printed in the school's light-blue color, shows a series of graduation caps and tassels. (Courtesy Tom Plagens.)

COMMENCEMENT
nineteen hundred and eighty-one

SPRING BRANCH SENIOR HIGH SCHOOL

SPRING BRANCH HIGH

Student Handbook

In 1980, Ken Smert created the cover art for the *Spring Branch High Student Handbook*. The handbook outlined school policies and procedures and was given to students at the start of the school year. (Courtesy Tom Plagens.)

The Galveston County

A & M CLUB

Certifies

that _Darrell Tully_

Head Football Coach of Ball High School

has been selected for

TEXAS SCHOOLBOY COACH of YEAR

in _Football_ for the season of _1954_

Thomas H. Lyles
PRESIDENT

Fred C. Jackson
ATHLETIC CHAIRMAN

Raymond G. Busby
SECRETARY

In 1954, the A&M Club of Galveston selected Darrell Tully as Texas Schoolboy Coach of the Year. Tully coached at Ball High School in Galveston before moving to Spring Branch High School in 1957. (Courtesy Terry Tully Ondriska.)

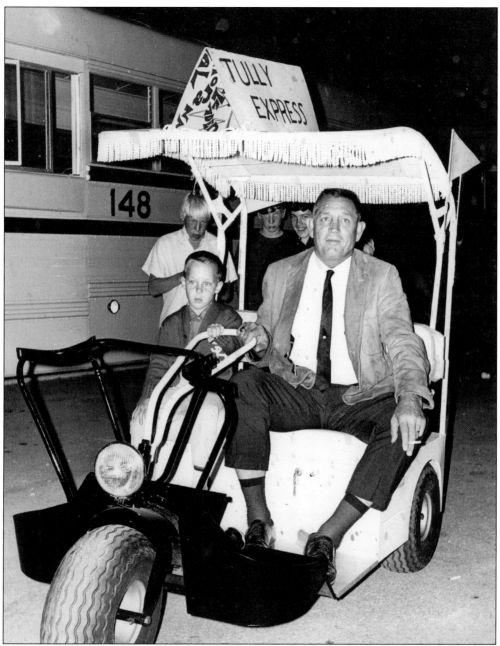

Darrell Tully enjoys a ride on the "Tully Express," which was set up for him as part of a retirement celebration in 1978. Tully coached at Spring Branch High School from 1957 to 1963. The most famous of Tully's players was Chris Gilbert, who went on to become a three-time All–Southwest Conference running back, playing for coach Darrell Royal at the University of Texas. (Courtesy Terry Tully Ondriska.)

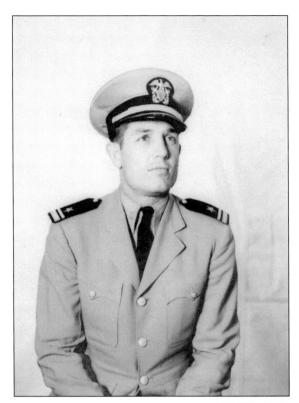

Like many athletes and coaches of his generation, Tully set aside his career when the United States entered World War II in December 1941. Tully served in the Navy. (Courtesy Terry Tully Ondriska.)

This portrait of Darrell Tully was taken in anticipation of an honors banquet at his alma mater, East Texas State Teachers College (currently known as Texas A&M–Commerce). After his retirement from coaching, Tully stayed on as the Spring Branch Independent School District athletic director and saw the district expand to six high schools. (Courtesy Terry Tully Ondriska.)

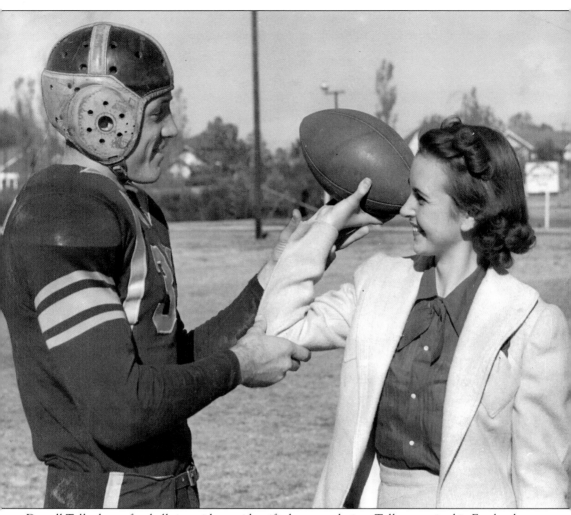

Darrell Tully shares football tips with a unidentified young admirer. Tully was raised in Eastland, which is west of Fort Worth, and became a star player at East Texas State Teachers College (now Texas A&M–Commerce). (Courtesy Terry Tully Ondriska.)

Don Coleman, pictured here in 1958, served as the Memorial High School basketball coach from the school's opening in 1962 until his retirement in 1992. His 1966 team won the state championship, and at one point the Mustangs had an impressive 81-game winning streak. (Courtesy Brandon Coleman Jr.)

Darrell Tully is remembered for his football coaching and his athletic administration career, but he also coached other sports, including basketball. One can imagine how this drill, in which the player is blindfolded, could help improve basketball skills. (Courtesy Terry Tully Ondriska.)

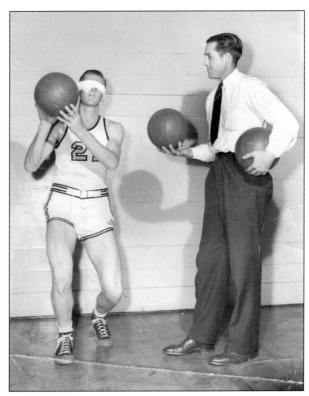

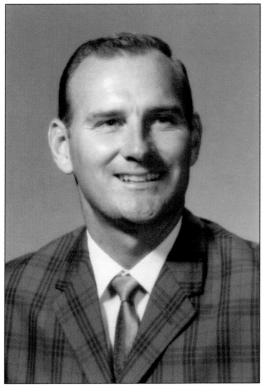

Don Coleman grew up in Port Arthur and graduated from Lamar Tech (currently known as Lamar University) before going into coaching. He coached at Aldine High School in the Aldine Independent School District before moving to Memorial High School in 1962, when this picture was taken. Memorial was the second high school opened in the district. (Courtesy Brandon Coleman Jr.)

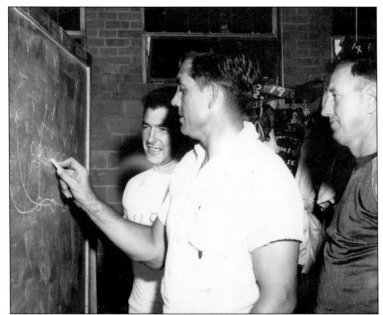

Darrell Tully (center) diagrams football plays on the blackboard for his assistant coaches Fred Herring (left) and Joe Taylor. Tully was passionate about football, following not only the high schools with which his teams competed, but college and professional teams as well. (Courtesy Terry Tully Ondriska.)

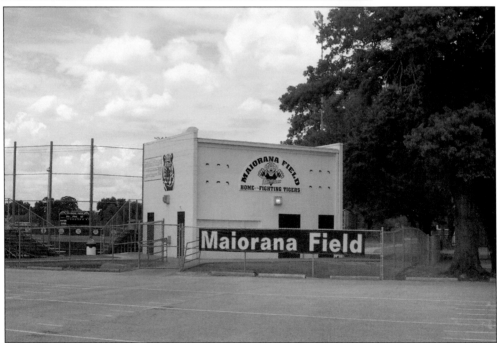

Charles "Charlie" Maiorana grew up in the Spring Branch area and, after graduating from college, returned to Houston to begin his teaching and coaching career. Maiorana was the longtime baseball coach at Spring Woods High School, where his teams won numerous district titles. He served as president of the Texas High School Baseball Coaches Association in 1988–1989 and was inducted into its hall of fame in 1993. In April 2010, the school district renamed the Spring Woods baseball field in Maiorana's honor. The most famous of Maiorana's players was Roger Clemens, who later won seven Cy Young Awards over a 24-year professional baseball career. (Photograph by George Slaughter.)

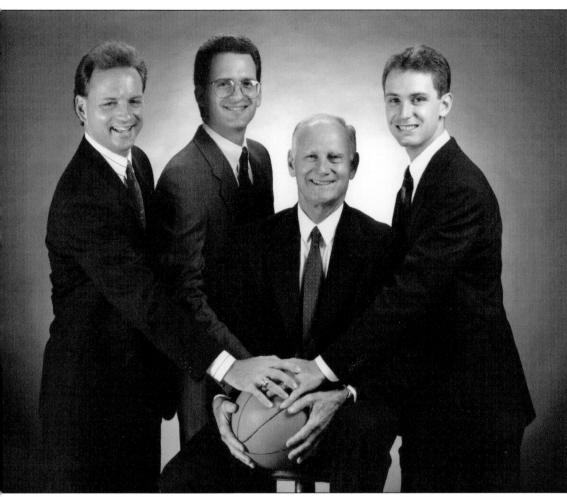

Coach Brandon "Don" Coleman (seated) poses with his three sons, standing from left to right, Brandon Coleman Jr., Kevin Coleman, and Scott Coleman. Brandon Jr. served on the Spring Branch Independent School District Board of Trustees, spending an unprecedented three years as board president. (Courtesy Brandon Coleman Jr.)

High school basketball players face a challenge every time they take the floor. In this 1971 image, the Memorial Mustang players are joined by coaches and a fan while looking for a missing contact lens. (Courtesy Brandon Coleman Jr.)

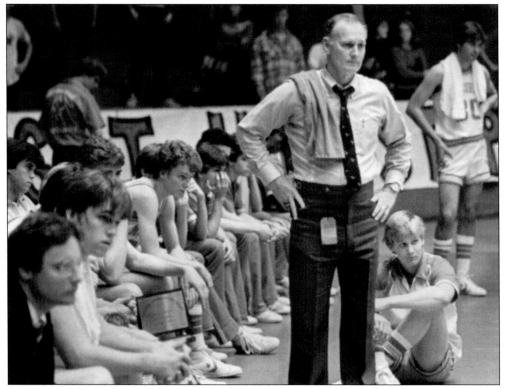

One of coach Don Coleman's trademarks was a red hand towel, shown here slung over his right shoulder. Coleman is remembered for his commitment to physical conditioning, instructing his players to run five miles before every practice; this way, they were better conditioned to play in the fourth quarters of games. (Courtesy Brandon Coleman Jr.)

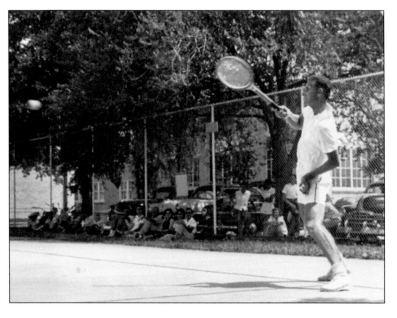

Don Coleman is remembered around Spring Branch as the longtime Memorial High School boys' basketball coach, but he was also a tennis player and coached that sport for some years. In this 1957 photograph, he plays in front of an audience which has wisely chosen to sit in the shade on a hot Texas day. (Courtesy Brandon Coleman Jr.)

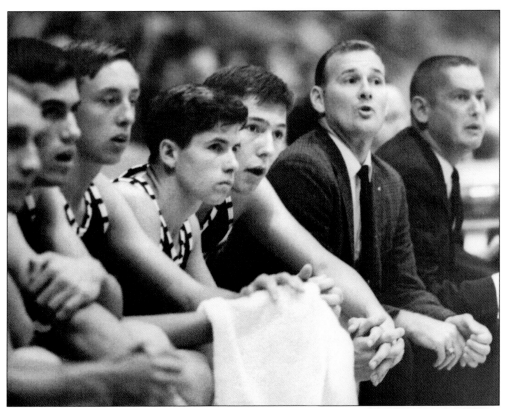

Coach Don Coleman (second from right) follows developments during the 1966 Texas High School All-Star Game, at which he coached. He also coached in the 1992 all-star game. In 1996, Coleman was named to the Texas High School Coaches Hall of Fame. (Courtesy Brandon Coleman Jr.)

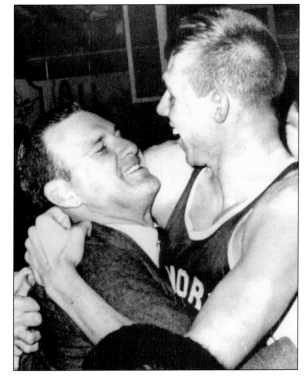

Coach Coleman hugs one of his players, Jerry Kroll, after the Memorial Mustangs won the 1966 state basketball championship. Kroll went on to play college basketball and had a short stint in professional basketball. (Courtesy Brandon Coleman Jr.)

The 1966 Memorial High School boys' basketball team held a 25-year reunion in 1991 to commemorate its state championship. Coach Don Coleman is seated on the far left. (Courtesy Brandon Coleman Jr.)

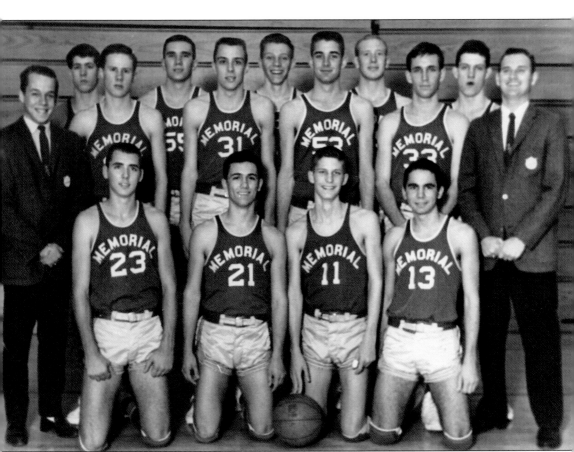

This 1966 Memorial High School boys' basketball team won the state championship. The seniors in 1966 were in the first four-year class to graduate from Memorial, which opened in 1962. (Courtesy Brandon Coleman Jr.)

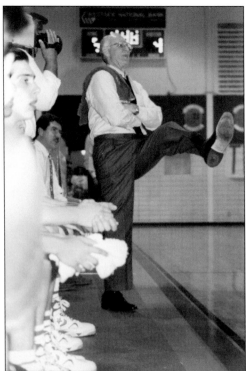

Like most coaches, Don Coleman was passionate about his sport and his team. Sometimes he would react to events by kicking up his leg, as shown here. On other occasions, he would nervously pull up his socks while sitting on the bench. (Courtesy Brandon Coleman Jr.)

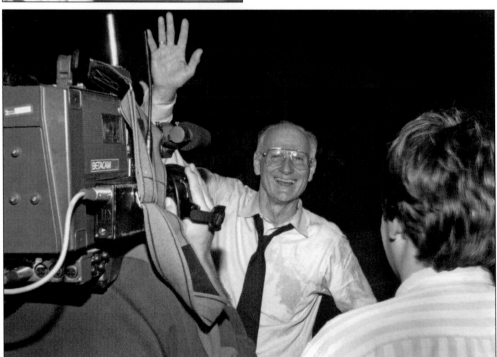

Don Coleman retired from coaching in 1992. Here, he waves to the crowd in appreciation. His Aldine and Memorial teams won 893 games against 331 losses, a .730 winning percentage. (Courtesy Brandon Coleman Jr.)

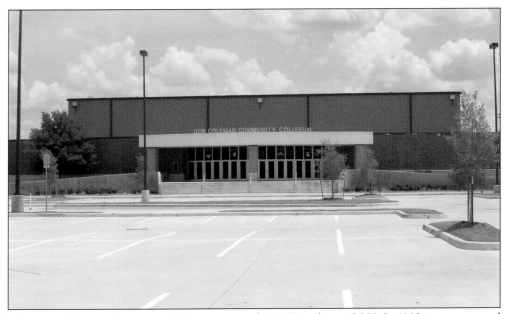

The Spring Branch Community Coliseum opened in 1974 and seats 5,000. In 1992, it was renamed in honor of longtime Memorial High School boys basketball coach Don Coleman. The coliseum serves as a venue for home basketball and volleyball games and tournaments, as well as awards banquets and graduation ceremonies. (Photograph by George Slaughter.)

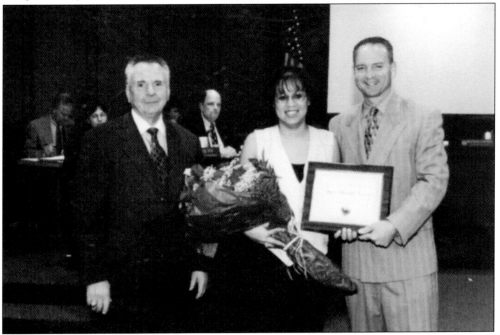

Hal Guthrie (left) joins Spring Branch Independent School District school board president Brandon Coleman Jr. (right) in honoring Dalia Murphy Flores as SBISD Employee of the Month in June 2005. Guthrie served as superintendent from 1985 to 2001. The school district named a career center, where high school students can take courses in such subjects as architectural design, culinary arts, and graphic design, in his honor. (Courtesy Brandon Coleman Jr.)

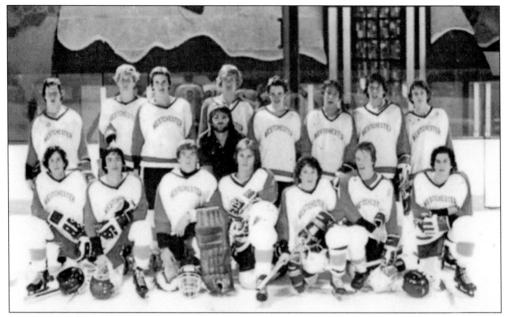

Spring Branch and the Greater Houston area may not be known for cold winters, but they do have a share of ice hockey fans. This photograph shows the 1978 Westchester High School hockey team. Two of its players—Gord Dineen (first row, fifth from left) and Kevin Dineen (second row, far left)—eventually played in the National Hockey League. (Courtesy Ralph Devine, WestchesterWildcats.com.)

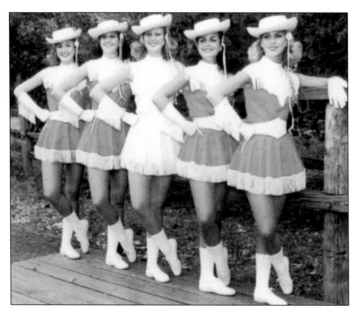

The Westchester High School Wranglerettes drill team performed at football games and other school-sponsored events. This photograph shows the 1985 Wranglerette officers, the last such group before the school district closed Westchester High School and converted it into the Westchester Academy of International Studies. (Courtesy Ralph Devine, WestchesterWildcats.com.)

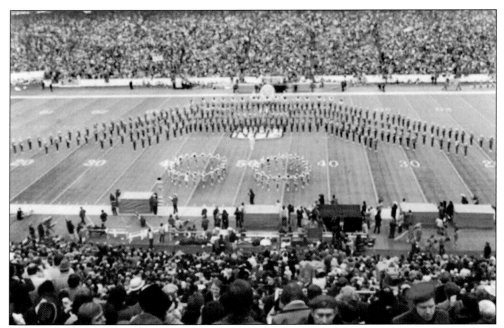

The Westchester Wranglerettes performed at many events, including the 1974 Super Bowl, which was played at Rice Stadium in Houston. In that game, the Miami Dolphins won their second consecutive championship by defeating the Minnesota Vikings 24-7. (Courtesy Ralph Devine, WestchesterWildcats.com.)

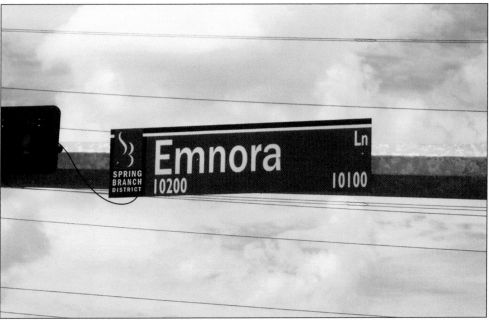

In an effort to encourage community identity and pride, the Spring Branch Management District recently began installing new street signs for the area it covers. This sign is for Emnora Lane, located in west Spring Branch. The sign might be new, but the name "Emnora" comes from Emma Neuen Beinhorn and Lenora Neuen Bauer, daughters of August Neuen, who owned the property where the road was built. (Photograph by George Slaughter.)

Discover Thousands of Local History Books
Featuring Millions of Vintage Images

Arcadia Publishing, the leading local history publisher in the United States, is committed to making history accessible and meaningful through publishing books that celebrate and preserve the heritage of America's people and places.

Find more books like this at
www.arcadiapublishing.com

Search for your hometown history, your old stomping grounds, and even your favorite sports team.

Consistent with our mission to preserve history on a local level, this book was printed in South Carolina on American-made paper and manufactured entirely in the United States. Products carrying the accredited Forest Stewardship Council (FSC) label are printed on 100 percent FSC-certified paper.

MADE IN THE USA